COMISKEY PARK

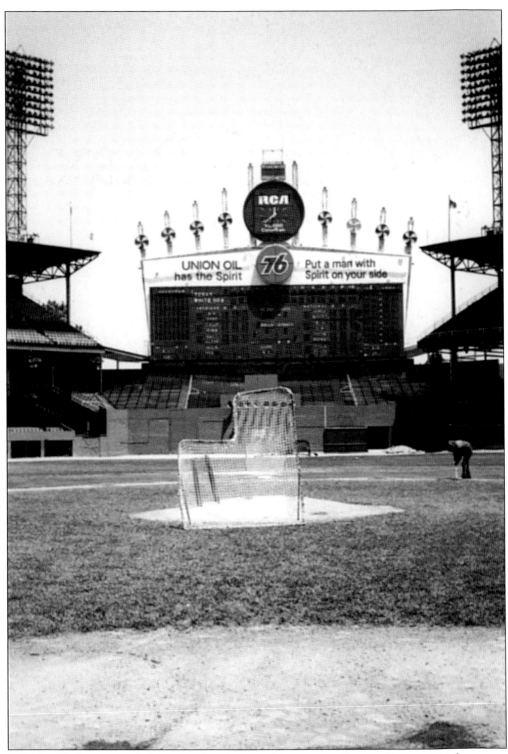

Bill Veeck's famous exploding scoreboard loomed large even from well over 400 feet away. (Photo by author.)

COMISKEY PARK

Irwin J. Cohen

ARCADIA

Copyright © 2004 by Irwin J. Cohen.
ISBN 0-7385-3244-4

Published by Arcadia Publishing,
an imprint of Tempus Publishing, Inc.
Charleston SC, Chicago, Portsmouth NH,
San Francisco

Printed in Great Britain.

Library of Congress Catalog Card Number: 2004100104

For all general information contact Arcadia Publishing at:
Telephone 843-853-2070
Fax 843-853-0044
E-Mail sales@arcadiapublishing.com

For customer service and orders:
Toll-Free 1-888-313-2665

Visit us on the internet at http://www.arcadiapublishing.com

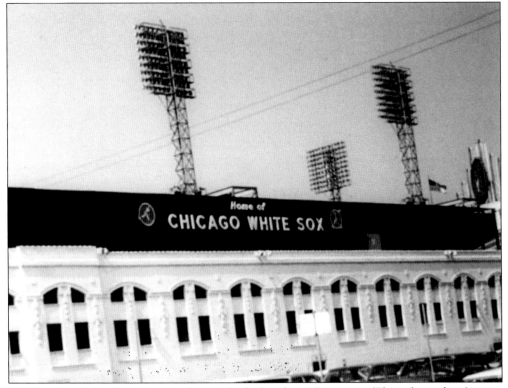

Bill Veeck had the dark exterior whitewashed after the 1959 season. (Photo by author.)

CONTENTS

ACKNOWLEDGMENTS

One advantage of being in my early sixties is that I have vivid memories of the early 1950s. I'll never forget that Sunday in August of 1951.

I was living in Detroit at the time and throwing a rubber ball against the front steps of our house while listening to the goings-on of the Tigers and Browns battling it out for last place in St. Louis.

All of a sudden, play-by-play man Van Patrick mixed excitement and laughter as he described three-foot, seven-inch Eddie Gaedel walking to the plate and subsequently walking on four straight pitches.

Bill Veeck, owner of the St. Louis Browns at the time, would forever be remembered for that historic at-bat. Veeck also endeared himself to me forever.

Here I was, the smallest kid in the class. Yet, I was taller than a major leaguer. I rooted for Veeck from that moment on and followed him through both of his White Sox ownerships.

When Veeck was in his second tenure as White Sox owner, I was operating the Baseball Bulletin, a national baseball monthly. Comiskey Park became a favorite destination. Veeck and Don Unferth of the front office supplied me with numerous photos and good times. I told them that some day I would love to do a book on the history of Comiskey Park and would use some of the photos then, besides using them for the publication I was operating at the time.

While I have special memories of Veeck and Unferth, a special thank you goes to "Dr. Ballpark," Ray Mediros. The photos he took and acquired through the decades deserve a special place in the Hall of Fame.

Another special man is the legendary Ernie Harwell. The former voice of the Tigers experienced Comiskey Park for decades, and his White Sox collection, now housed in the Burton Historical Collection of the Detroit Public Library and ably managed by David Lee Poremba, was invaluable. When you see "EHC, BHC, DPL" in parentheses after a photo, it stands for "Courtesy of Ernie Harwell Collection of the Burton Historical Collection of the Detroit Public Library."

Thanks also to B&W Photos of Sylmar, California; Sports Legends Photos, Inc., of Hallandale, Florida; and Dennis Jose of Chicago Promotions.

The photos here of Charles Comiskey's park and some of the players who represented the White Sox, mixed with our favorite memories, will forever keep that unique old place at 35th and Shields alive.

INTRODUCTION

Thirty-fifth and Shields.

Comiskey Park was the address of some of baseball's most historic moments, especially during the period between World War I and World War II. Charles Comiskey named the ballpark that he built and opened in 1910 after himself. After all, no one deserved it more. Comiskey, who was born in Chicago in 1859 to a father who was the first head of Chicago's City Council, was an innovator as a player, manager, and owner.

A first baseman, Comiskey played during an era when players at his position kept one foot on the bag and both eyes on the action. Comiskey pioneered the move away from the base. A savvy manager, he led the St. Louis Browns to four consecutive pennants from 1885 to 1888. Comiskey purchased and moved the Western League St. Paul, Minnesota franchise to Chicago for the 1900 season and helped the league reinvent itself as the American League the following year. He picked a popular name for his new club—the White Stockings, which had been used by Chicago's National League team in the 1870s and 1880s.

The club leased the Chicago Cricket Club's South End Grounds at 39th Street between Wentworth and Princeton. The name and team were popular, winning the Western League title in 1900 and the American League pennant in 1901. However, the site had a limited seating capacity of only 7,500.

Within two years, Comiskey was planning a new stadium designed to be the best in the big leagues. When it opened on July 1, 1910, at 35th and Shields, Comiskey boasted his baseball park was the "Baseball Palace of the World." 28,000 fans filled the seats and bleacher spaces at its opening, but the crowd was disappointed as the home team lost, 2-0.

There were many low scoring games in Comiskey Park, as the original dimensions favored pitchers, with 362-foot foul lines and 440 feet to center field. The White Sox won their first pennant in Comiskey Park in 1917 and their second two years later. The year 1920 looked like another great one for the White Sox; however, during the season the scandal involving eight members of the 1919 White Sox club broke. The players accused of accepting bribes from bettors and bookmakers were suspended forever in what became known as the "Black Sox Scandal."

Comiskey Park was renovated and expanded in 1926. The stands were double-decked almost all around, except for a small bleacher area in center field. The ballpark still favored pitchers, even though foul line distances were reduced by ten feet, to 352.

Comiskey owned the White Sox from 1900 until his death in 1931, and his club topped the American League five times during that period.

The 1933 World's Fair, called the Century of Progress, was held in Chicago. Arch Ward, of the Chicago Tribune, felt it would be a great showcase for introducing the sport of baseball to visitors from different parts of the world. Ward pushed for an exhibition game featuring baseball's best players from each league. Thus the All-Star Game was born, and Comiskey Park was the site on July 6, 1933. Babe Ruth homered before 47,595 fans, giving the Ameican League a 4-2 win over the National League. The Negro Leagues also held their All-Star Games in Comiskey Park in the 1930s.

In 1937 Comiskey Park hosted the heavyweight title fight between Joe Louis and James Braddock. It was the second of five heavyweight fights the ballpark would host. About two years after Braddock went down, lights went up and the Sox played their first night game in Comiskey on August 14, 1939.

In 1947 Larry Doby broke the American League color barrier when the Sox hosted the visiting Cleveland Indians. A few months later, the Chicago Cardinals won the 1947 National Football League title in Comiskey Park when they defeated the Philadelphia Eagles, 28-21.

The bullpens along the foul lines were removed in 1950 and placed in front of the center field wall, shaving the distance from 440 feet to 415. In 1952 the large electronic scoreboard went up on top of the center field bleachers, and even though newer boards replaced older ones, Comiskey Park retained the same look until its last game in 1990.

Paint jobs, dashes of color, exploding scoreboards, beer halls, showers, and a barber's chair in the bleachers all made their debut and faded into history. But memories of colorful owners, managers, players, announcers, fans, and the park that housed them will linger forever within those who experienced them.

ONE

The Early Years

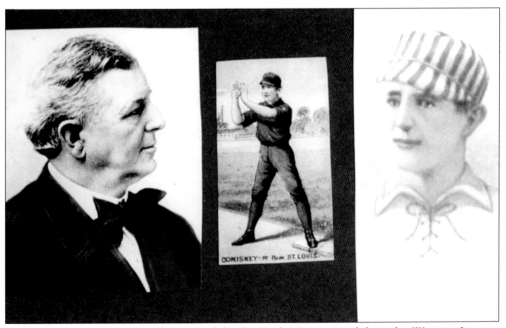

A first baseman, manager and owner of the St. Paul, Minnesota club in the Western League, Charles Comiskey moved the team to his native Chicago for the 1900 season and leased the home grounds of the Chicago Cricket Club at 39th and Wentworth. (Author's collection.)

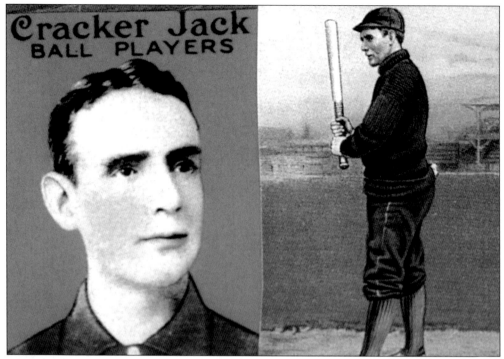

Clark Griffith, a veteran pitcher who played other positions for Chicago's National League club, was signed by Charles Comiskey after the 1900 season as the White Sox would be a charter member of the American League. (Author's collection.)

Griffith managed the 1901 White Sox to the pennant and inserted himself as a pitcher in 35 games. After finishing fourth in 1902, Griffith moved on to New York. He would go on to own the Washington Senators and have a ballpark named for him. (Author's collection.)

Roy Patterson pitched for the White Sox for seven years starting in 1901 when he won 20 games, helping the team win the pennant in the American League's first season. (Courtesy EHC, BHC, DPL.)

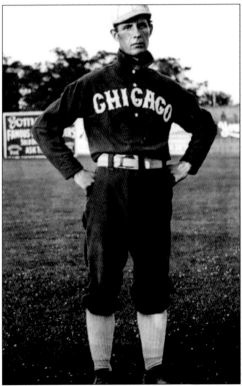

A White Sox outfielder since 1901, Fielder Jones was installed as player-manager during the 1904 season and guided the White Sox to the pennant in 1906. The White Sox became known as the "Hitless Wonders" as the team batting average was only .228 with six home runs. (Courtesy EHC, BHC, DPL.)

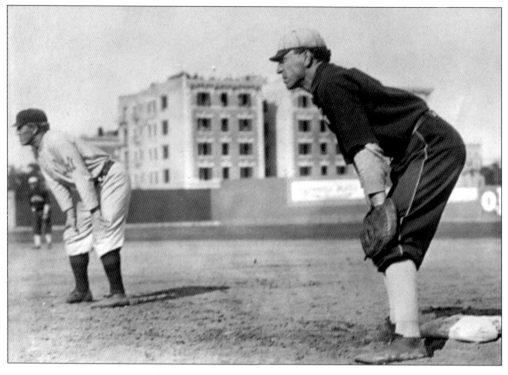

Above: Shortstop George Davis had a high batting average of .277 for the "Hitless Wonders." Davis helped the Sox beat the crosstown Cubs in the World Series by batting .308.

Left: First baseman Jiggs Donahue hit .257 with one home run in the 1906 season and batted .333 in the World Series.

Nick Altrock, who teamed as part of a baseball clown act, loved to look back on his pitching career with the White Sox, during which he won 61 games from 1904 through 1906.

Owner Charles Comiskey proudly watches the raising of the World Championship flag in 1907. (Photos courtesy EHC, BHC, DPL.)

After a fight with New York Highlanders manager Clark Griffith, speedy Pat Dougherty came to the White Sox and became a regular outfielder through 1910. Dougherty led the league in stolen bases with 47 in 1908.

Frank "Piano Mover" Smith won 23 games in 1907 and 25 in 1909.

A talented violinist and songwriter, George "Doc" White graduated as a dental surgeon from Georgetown University. White pitched for the White Sox for ten years and won 27 games in 1907. Ty Cobb called the lefty the toughest pitcher he ever faced. (Photos courtesy EHC, BHC, DPL.)

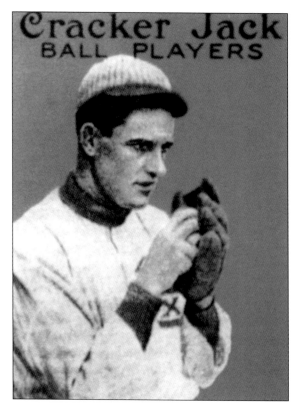

Spitballer Ed Walsh won 40 games in 1908 after winning 24 in 1907. He would record remarkably low earned run averages of 1.88, 1.60, 1.42, 1.41 and 1.27 from 1906 through 1910. (Author's collection.)

In 1909 Jake Atz wound up his playing career with the White Sox with no home runs in 604 career at-bats and an average of .219. Atz went on to be an umpire and won six straight pennants while managing Fort Worth in the Texas League. (Courtesy EHC, BHC, DPL.)

TWO
Comiskey's Park and Players

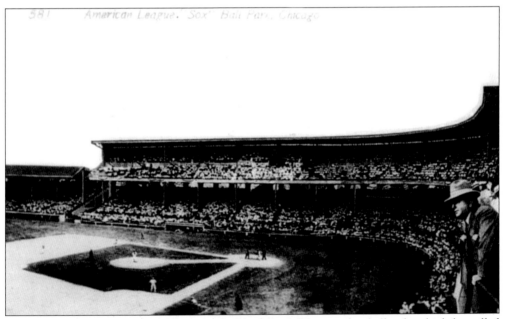

Charles Comiskey peers over the upper deck railing as he opens his ballpark, which he called the "Baseball Palace of the World," on July 1, 1910. (Courtesy Ray Mediros.)

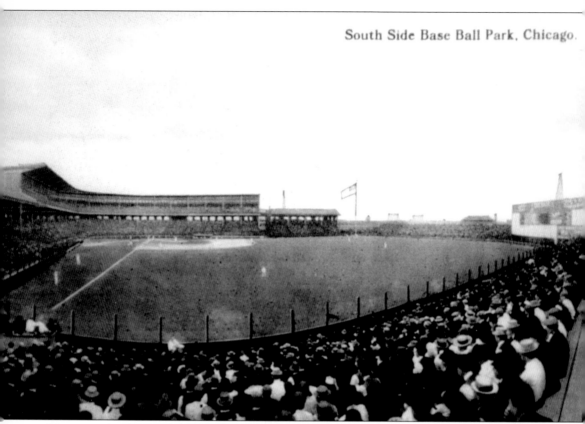

Twenty-eight thousand fans paid their way into Comiskey Park, but the visiting St. Louis Browns defeated the White Sox, 2-0. The bleachers in right and left field had 7,000 of the ballpark's 32,000 seats. Foul lines measured 362 feet, and the centerfield wall was 440 feet from home plate. (Courtesy Ray Mediros.)

The first home run in the spacious ballpark was hit by Lee Tannehill on July 31, 1910. Tannehill, an infielder, played for the White Sox from 1903 to 1912.

Hugh Duffy, who hit .440 in 1894—the highest batting average of all time—managed the White Sox in 1910 and 1911. (Courtesy EHC, BHC, DPL.)

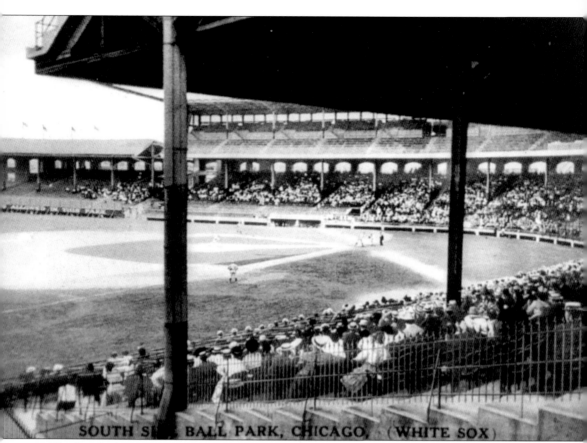

SOUTH S[IDE] BALL PARK, CHICAGO, (WHITE SOX)

The fourth place White Sox drew 583,208 fans in the 1911 season, an increase of over 31,000 from the previous season's sixth place club. (Courtesy Ray Mediros.)

William J. "Kid" Gleason was no kid, but 45 years old when he wrapped up his 22-year playing career with the White Sox in 1912. Seven years later he became White Sox manager, and the former pitcher and infielder skippered the south-siders through the 1924 season. (Courtesy EHC, BHC, DPL.)

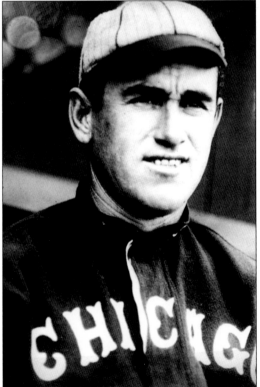

Outfielder Matty McIntyre also ended his 10-year career in 1912, after two seasons with the White Sox. McIntyre died eight years later in a Detroit hospital after suffering from the flu and Bright's disease. (Courtesy EHC, BHC, DPL.)

Catcher Ray Schalk began his Hall of Fame career in 1912 at the age of 19. (Author's collection.)

Rookie Reb Russell pitched a one-hitter in 1913 and led the White Sox with 21 wins and number of innings pitched. (Author's collection.)

Speedy third baseman Harry Lord totaled 42 triples in the period covering the 1911 through 1913 seasons.

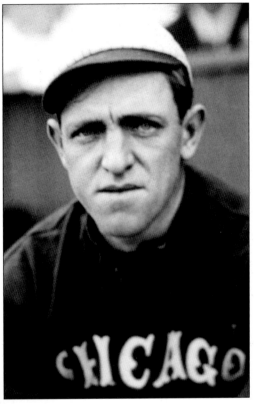

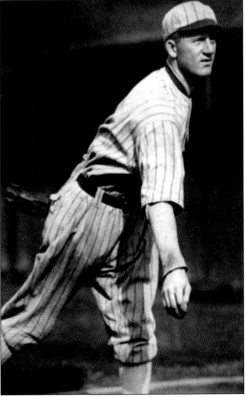

Urban "Red" Faber began his 20-year pitching career with the White Sox in 1914. (Courtesy EHC, BHC, DPL.)

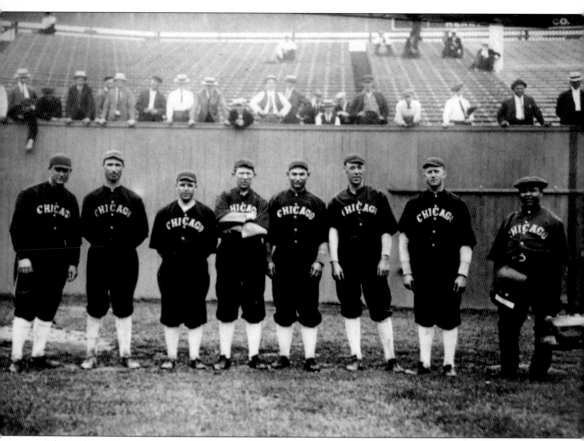

The White Sox pitchers of 1914, from left to right, were Ed Walsh, Jim Scott, Ed Cicotte, Joe Benz, Reb Russell, Bill Lathrop, and Urban "Red" Faber (beside an unidentified employee at right). Benz, who pitched for the White Sox from 1911 to 1919, pitched a no-hitter on May 31, 1914. (Courtesy EHC, BHC, DPL.)

A catcher for the White Sox since 1901, Billy Sullivan chats with Detroit Tigers owner Frank Navin. Sullivan finished his playing career with the Sox in 1914 and would be managing Navin's Tigers two years later. (Courtesy EHC, BHC, DPL.)

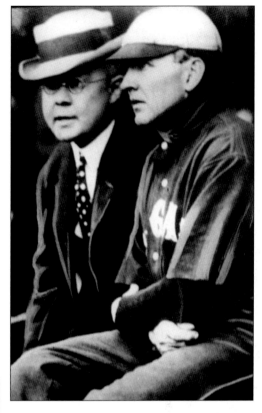

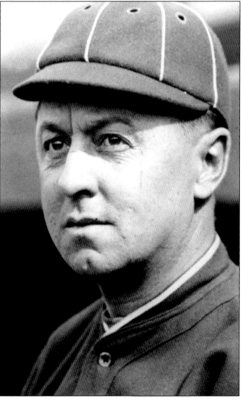

Clarence "Pants" Rowland became White Sox manager in 1915. Rowland would eventually umpire in the American League, serve as president of the Pacific Coast League, and become an executive with the Cubs. (Courtesy EHC, BHC, DPL.)

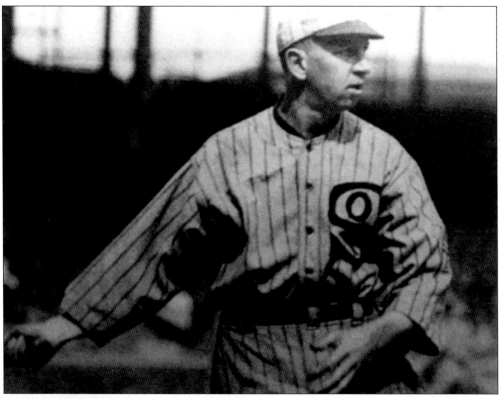

Above: After seven seasons with Connie Mack's Philadelphia Athletics, second baseman Eddie Collins, one of the greatest all-around players of all time, came to the White Sox in 1915 and hit .332 while drawing a league-leading 119 walks.

Left: A speedy center fielder with a great arm, Oscar "Happy" Felsch started his big league and White Sox career in 1915. (Courtesy EHC, BHC, DPL.)

The White Sox purchased the contract of outfielder "Shoeless" Joe Jackson from Cleveland for $31,500 on August 20, 1915. Jackson hit .408 for Cleveland in 1911. (Courtesy Sports Legends Photos.)

Dave Danforth, who pitched for the Athletics in 1911 and 1912 before being sent to the minors, came up with the White Sox in 1916. After a mediocre major league career, Danforth starred in the minors before turning to coaching at Loyola College. He became Dr. Danforth and practiced dentistry in Baltimore until retiring in 1960.

Outfielder Harry Nemo Leibold, who had a 13-year big league career and spent the 1916 through 1920 seasons with the White Sox, remained in baseball as a minor league manager and scout before retiring in 1953. (Courtesy EHC, BHC, DPL.)

As Babe Ruth was making a name for himself by pitching nine shutouts for the pennant-winning Boston Red Sox, pitcher Ed Walsh closed out his 13-year career with the White Sox in 1916. Walsh pitched in four games with the Red Sox the following season before calling it quits with a 195-126 career record and an amazing lifetime ERA of only 1.82. Walsh umpired in the American League for a year and coached baseball at Notre Dame University. He was elected to the Hall of Fame in 1946. (Author's collection.)

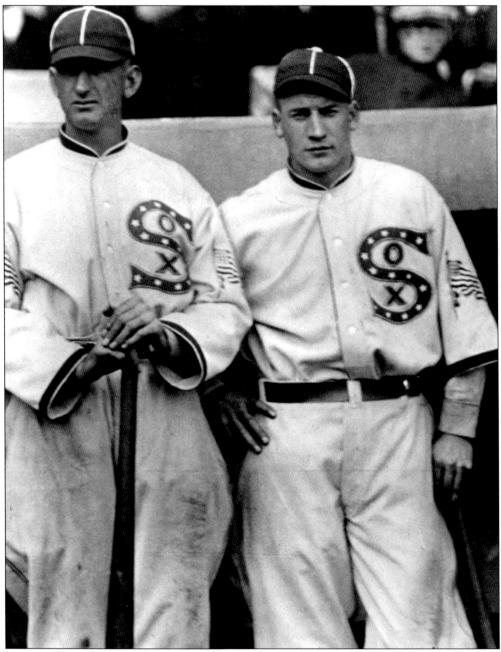

After finishing two games behind the Red Sox in 1916, the White Sox won 100 games and the pennant in 1917. They went on to defeat the New York Giants in the World Series. "Shoeless" Joe Jackson (left) had an off year but still batted .301. Happy Felsch led the club in batting average (.308), home runs (8), and RBIs (102). (Courtesy B&W Photos.)

Jim Scott, who pitched for the White Sox starting in 1909, wrapped up his excellent career at age 29 in 1917. While Scott lost more games (113) than he won (107), his career ERA was an outstanding 2.32. He once pitched a shutout in 68 minutes. Scott would serve in World War I and become an electrician at California movie studios.

Swede Risberg, a shortstop with a shotgun arm, began his big league career with the White Sox in 1917. Many would blame him for the scandal two years later. (Courtesy EHC, BHC, DPL.)

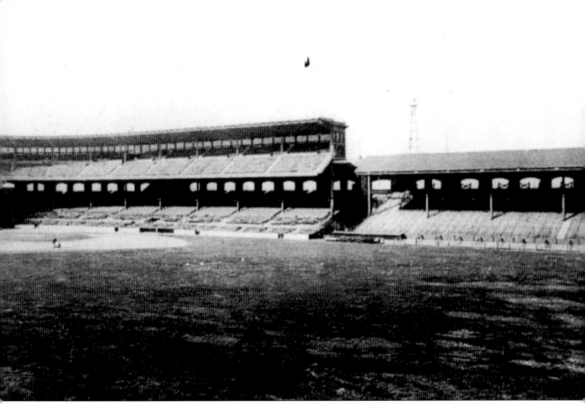

After winning it all in 1917, the White Sox skidded to sixth place and only 57 victories, 43 less than the year before, in the 1918 season. Because of the team's poor showing and many men serving in the military during World War I, attendance dropped to 195,081 from a Comiskey Park high of 684,521 in 1917. (Courtesy Ray Mediros.)

Former pitcher and infielder Kid Gleason became manager in 1919 and guided the White Sox to a first place finish while attendance went up to 627,186.

"Shoeless" Joe Jackson led the team in 1919 with a .351 average and 96 RBIs. Jackson hit .375 in the World Series in 32 at-bats. (Courtesy EHC, BHC, DPL.)

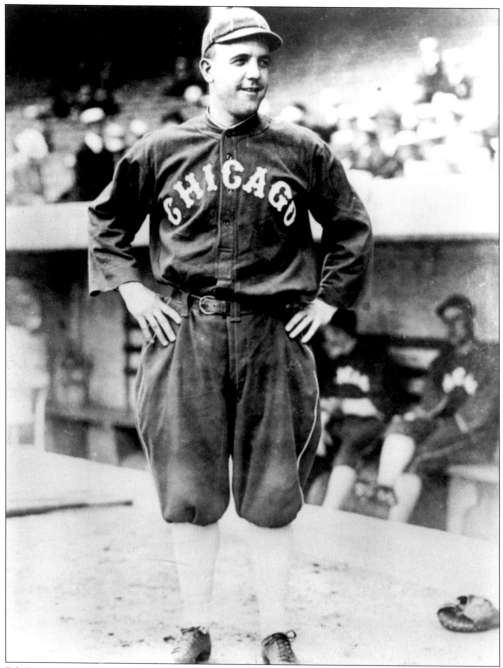

Ed Cicotte won 29 games in 1919 and was the American League leader in complete games (30). However, the great pitcher accepted a bribe and Cicotte, normally a control pitcher, hit the first batter in the World Series to signal the gamblers that the fix was in. Cicotte then uncorked a wild pitch, bobbled a grounder, ignored the catcher's signals, and went on to lose two games in the Series against the Reds. (Courtesy B&W Photos.)

Third baseman Buck Weaver knew of the bribes and wasn't part of the plot. He starred in the World Series, hitting .324 with five extra base hits. However, his silence cost him his career as he would be banished from the game for his failure to expose his teammates.

Arnold "Chick" Gandil, a former hobo and boxer, was a graceful-fielding first baseman whose involvement with gamblers led to the recruitment of some key White Sox players to fix the World Series against the Reds. Gandil did his part to lose by hitting .233 and making an error in the Series. (Courtesy EHC, BHC, DPL.)

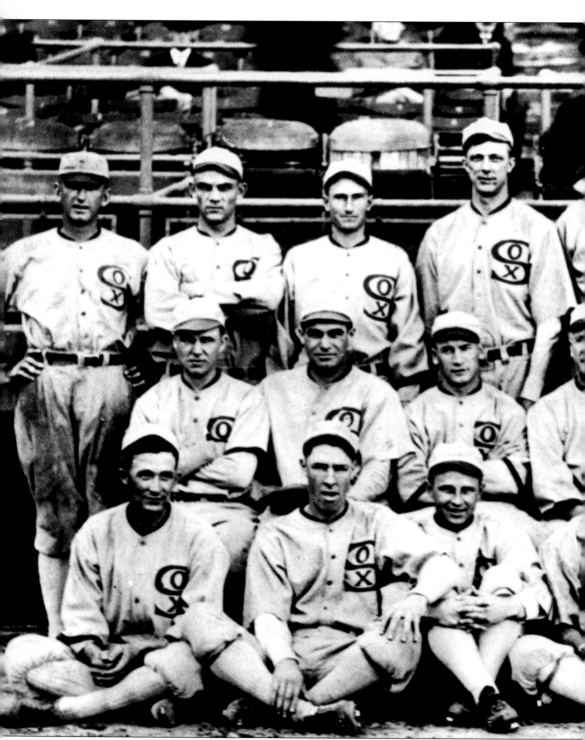

1919 Chicago White Sox, from left to right, are: (front row) Lynn, Risberg, Leibold, Kerr, McClellan, Williams, and Cicotte; (middle row) Schalk, Jenkins, Felsch, Gleason, E. Collins, J.Collins, Faber, and Weaver; (back row) Shoeless Joe Jackson, Gandil, McMullin,

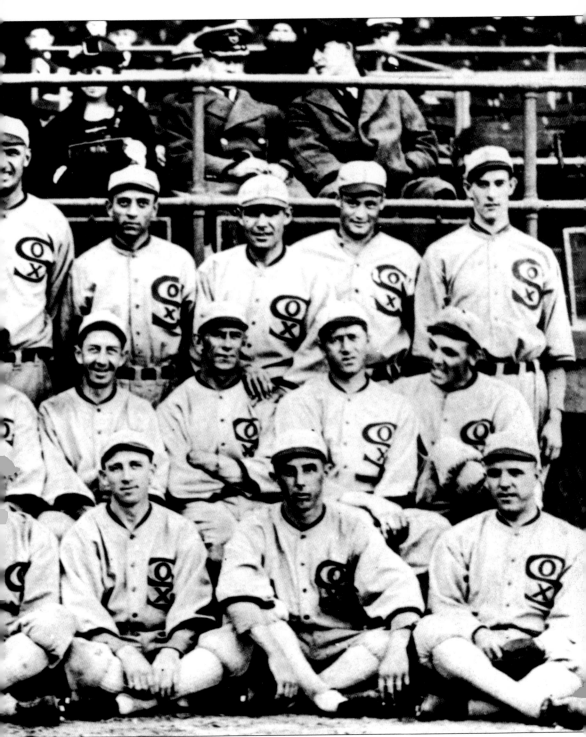

Lowdermilk, James, Maver, Murphy, Sullivan, and Wilkinson. Lackluster play against the Cincinnati Reds in the World Series eventually revealed that several key players accepted bribes in what became known as the "Black Sox Scandal." (Courtesy B&W Photos.)

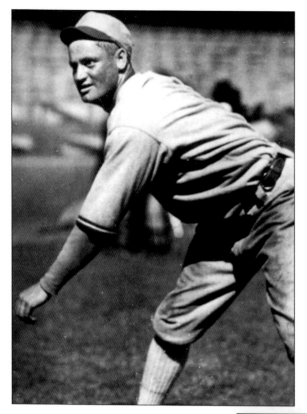

Teammates were rooting for likable Chicago native John "Lefty" Sullivan. However, Sullivan gave up 24 hits in only 15 innings over four games, ending his big league career with a 0-1 record and 4.20 ERA.

Arm troubles forced lefty Reb Russell to end his seven-year pitching career with the White Sox in 1919 with a nifty 81-59, 2.34 ERA. Russell would reinvent himself as an outfielder and would be back in the major leagues three years later with Pittsburgh, hitting .368 with 12 home runs in only 220 at-bats. (Courtesy EHC, BHC, DPL.)

In 1920 talk still centered on the previous World Series and the poor showing of Lefty Williams, who compiled a Series record of 0-3, 6.61 ERA after winning 23 games in the regular season. In 1920 Williams won 22 games and the second-place White Sox had four 20-game winners. Besides Williams, Red Faber won 23, and Ed Cicotte and Dickie Kerr finished with 21 victories each.

After a nine-year pitching career with six teams in which he won 23 and lost 39, Grover Lowdermilk was released by the White Sox in 1920 and became a coal miner. (Courtesy EHC, BHC, DPL.)

Aware of years-long grumbling by teammates over stingy owner Charles Comiskey's financial treatment of his players, catcher Ray Schalk was unaware some of his teammates accepted bribes, but felt some were deliberately playing below their capabilities. The 1920 season would be the last for several star White Sox players. Events led to a lifetime ban for pitchers Eddie Cicotte and Lefty Williams, outfielders Happy Felsch and Joe Jackson, first baseman Chick Gandil, shortstop Swede Risberg, third baseman Buck Weaver, and utility infielder Fred McMullin. (Courtesy EHC, BHC, DPL.)

THREE

Trying to Rebuild

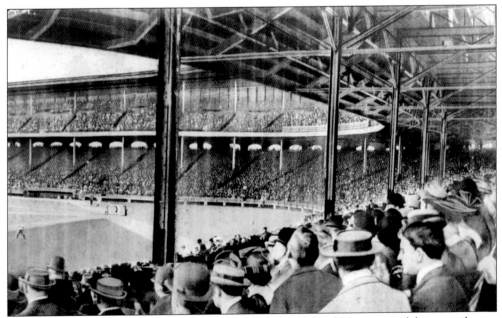

As several key White Sox players associated with the 1919 World Series scandal were no longer part of the team in 1921, attendance dropped from a Comiskey Park high of 833,492 in 1920 to 543,650 in 1921 as the club skidded to seventh place. (Courtesy Ray Mediros.)

After battting .303 in his eleventh season with the White Sox, John Shano Collins, a valuable first baseman-outfielder, was traded in 1921 to the Red Sox as part of the deal bringing Harry Hooper to the White Sox. Collins would be with Boston for five years and would serve two years as Red Sox manager.

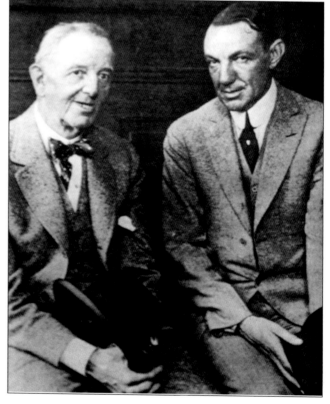

Charles Comiskey ponders the future without several of his key players as Cubs owner Bill Veeck, Sr., offers a sympathetic ear. (Courtesy EHC, BHC, DPL.)

Outfielder Harry Hooper hit .327 in his first season with the White Sox in 1921. Hooper wrapped up his 17-year big league career with the White Sox four years later. (Courtesy EHC, BHC, DPL.)

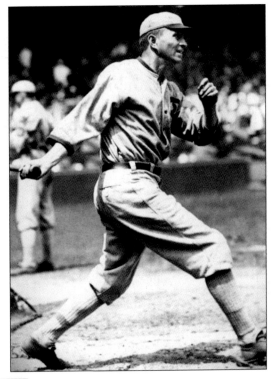

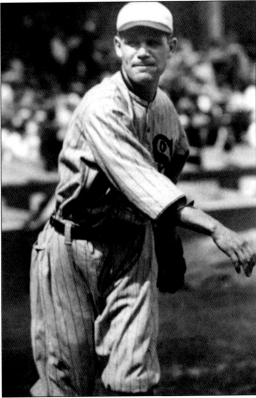

After ten years in the majors, the last four with the White Sox, outfielder Eddie Murphy would spend the next four years trying to play his way back to the big leagues. Murphy would resurface for a short time with Pittsburgh in 1926. (Courtesy EHC, BHC, DPL.)

43

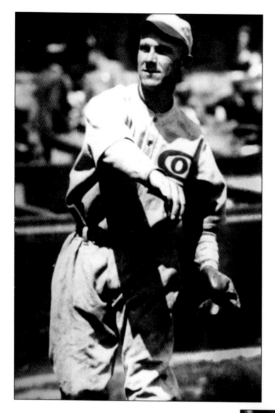

Ernie Johnson became the regular shortstop and hit .295 in 1921 after Swede Risberg's banishment. Johnson would stay with Chicago for two more seasons. He closed out his career with the Yankees and went on to manage and scout in the Red Sox system. Johnson is credited with signing several key players for Boston, including Bobby Doerr, Johnny Pesky, and Ted Williams. (Courtesy EHC, BHC, DPL.)

Rookie Charlie Robertson, 25, pitched a perfect game on April 30, 1922, against Ty Cobb's Detroit Tigers. Of the 27 outs, seven were ground balls, 14 were popped in the air, and six Tigers struck out. It was the only perfect game ever by a White Sox Pitcher. (Courtesy Don Unferth, Chicago White Sox.)

Ted Lyons, a future Hall of Famer and White Sox manager, made his pitching debut in relief on July 2, 1923.

Eddie Collins led the White Sox in batting average (.360) and stolen bases (47) in 1923 as the team finished seventh in its last season under manager Kid Gleason. (Courtesy EHC, BHC, DPL.)

Except for a perfect game in 1922, Charlie Robertson was an ordinary pitcher who posted 39-55 career numbers with the White Sox through 1925. Robertson would stay in the big leagues with the St. Louis Browns and Boston Red Sox for three more seasons, closing with a total career mark of 49-80, 4.44 ERA. He would go on to be a successful Texas pecan broker. (Courtesy EHC, BHC, DPL.)

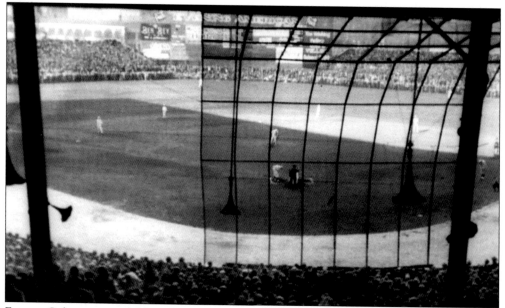

Former Cubs manager Johhny Evers was hired in 1924 and managed the White Sox to last place, resulting in his termination. Eddie Collins, the great shortstop, became player-manager in 1925 and 1926 and guided the team to fifth place finishes. Attendance was 710,339 in 1926. (Courtesy Ray Mediros.)

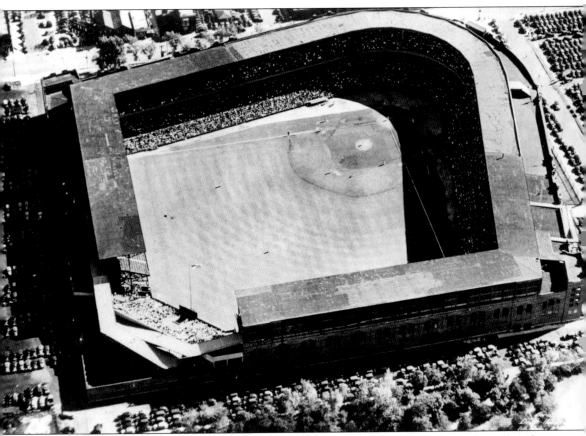

After the 1926 season, Charles Comiskey remodeled his ballpark with double-deck steel and concrete stands, replacing wooden bleachers. Comiskey Park was almost completely enclosed; only a small bleacher area in center field remained without a second deck. Before embarking on the expansion, Comiskey purchased additional land beyond right field which accommodated more rows of seating. Left field only had room for 19 rows in the lower deck, while right field had room for 31 rows. The upper decks in right and left field contained 20 rows of seating as the expansion added 23,200 seats, bringing capacity to 52,000. (Courtesy Sports Legends Photos.)

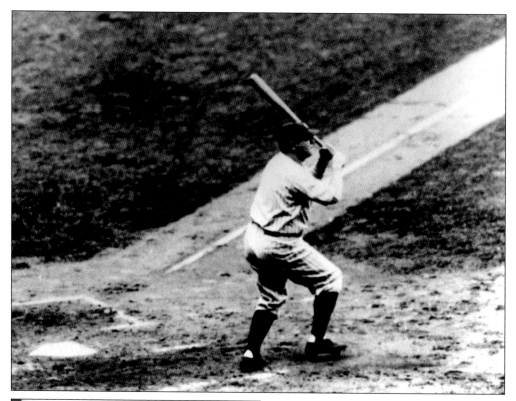

Above: On August 13, 1927, Babe Ruth became the first player to hit a fair ball out of the newly configured Comiskey Park. Ruth's blast cleared the roof at a point 75 feet high and 360 feet from home plate. (Courtesy B&W Photos.)

Left: John William "Bud" Clancy spent parts of the last three seasons with the White Sox. He was the club's starting first baseman in 1927 and responded with a .300 average. Clancy became a scout for the White Sox when his playing career ended. (Courtesy EHC, BHC, DPL.)

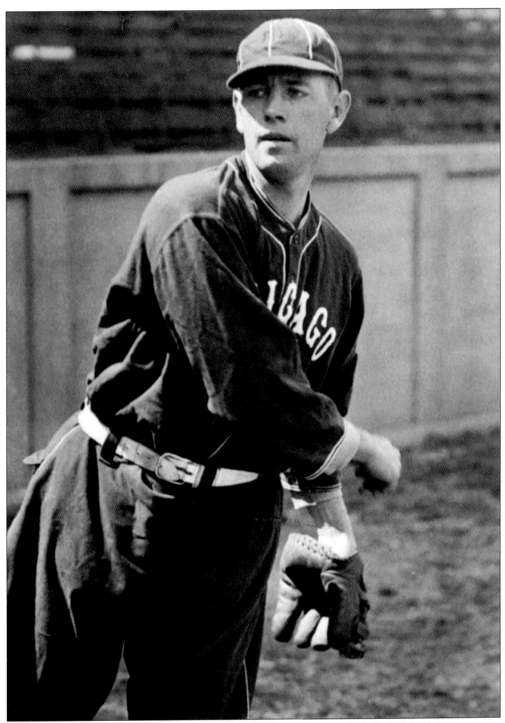

Ted Lyons, who pitched a no-hitter in 1926 and won 21 games, led the league in victories in 1927 with 22. (Courtesy Sports Legends Photos.)

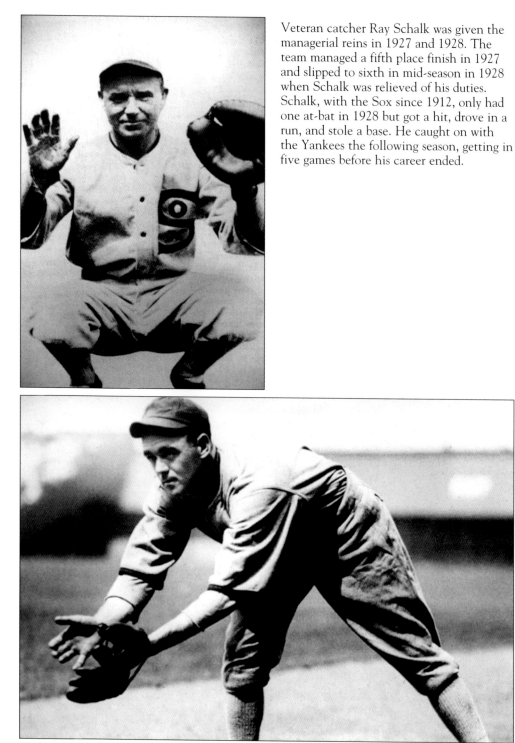

Veteran catcher Ray Schalk was given the managerial reins in 1927 and 1928. The team managed a fifth place finish in 1927 and slipped to sixth in mid-season in 1928 when Schalk was relieved of his duties. Schalk, with the Sox since 1912, only had one at-bat in 1928 but got a hit, drove in a run, and stole a base. He caught on with the Yankees the following season, getting in five games before his career ended.

Slick-fielding third baseman Willie Kamm came up to the White Sox in 1923. Kamm led American League third basemen in fielding average eight times and led the White Sox in hitting in 1928 with a .308 average. (Courtesy EHC, BHC, DPL.)

First baseman Art Shires, who nicknamed himself, "The Great," came up to the White Sox in 1928 and hit .341 in 33 games. In 100 games in 1929, Shires hit .312. He also hit the bottle and hit manager Lena Blackburn too often and was swapped to the Washington Senators.

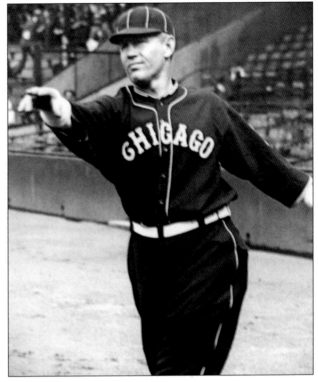

Speedy outfielder Johnny Mostil's big league career spanned the 1920s, all with the White Sox. He led the league in stolen bases in 1925 and 1926 and finished his playing career with a .301 average. Mostil became a scout and instructor with the White Sox. (Courtesy EHC, BHC, DPL.)

Smead Jolley, a jolly outfielder, spent 17 seasons in the minor leagues, compiling 336 home runs and a .367 batting average. Jolley made the majors with the White Sox in 1930 and hit .313 with 16 home runs. However, defensive liabilities would keep him from being a regular over the next three seasons, and he would return to the minors despite a .305 big league average.

Donie Bush, who previously managed Washington and Pittsburgh, led the White Sox to seventh place in 1930 and the basement in 1931. (Courtesy EHC, BHC, DPL.)

Charles Comiskey died at 72 after the 1931 season. He was called everything from cheap to shrewd and caricatured as an innovative player. (Courtesy Don Unferth, Chicago White Sox.)

A vaudeville singer in the off season, 10-year veteran infielder Lew Fonseca was traded to the White Sox in 1931 and became playing manager the following season, as Lou Comiskey, 46, Charles' son, was in charge of the franchise. (Courtesy B&W Photos.)

Ed Walsh, Jr., had a four-year big league career, all with the White Sox, which ended in 1932 after compiling a lifetime 11-24, 5.57 ERA. His record paled in comparison with his father's 195-126, 1.82 ERA over 14 years. Walsh, Jr., died at 31 in 1937 in his parents' home after being in a coma for a week from rheumatic fever. (Courtesy EHC, BHC, DPL.)

FOUR

More Changes for Comiskey

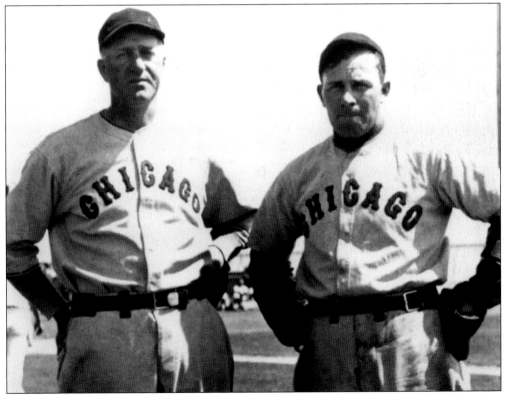

As Lew Fonseca's White Sox finished seventh in 1932, losing 102 games. Lou Comiskey spent $150,000 for Jimmy Dykes, Al Simmons, and Mule Haas from the Philadelphia Athletics as their owner, Connie Mack, needed funds to ride out the Great Depression. Veterans Red Faber (left) and newcomer Dykes were hoping for better performances in 1933. (Courtesy B&W Photos.)

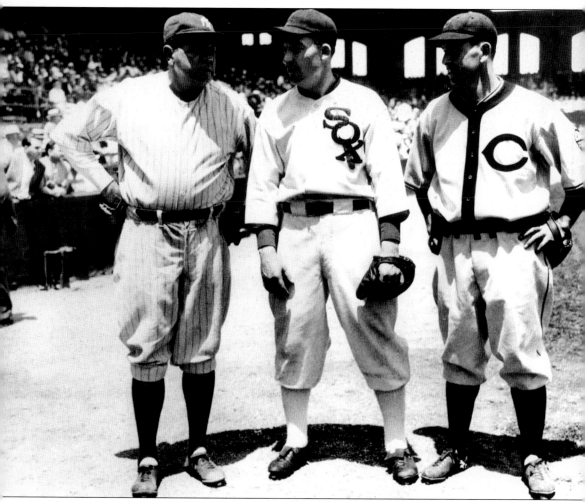

Chicago hosted the 1933 World's Fair, known as the Century of Progress. Arch Ward of the Chicago Tribune came up with the idea of an All-Star Game featuring baseball's best players from each league. Babe Ruth (left) greets Chicago All-Stars Al Simmons (White Sox) and Earl Averill (Cubs). (Courtesy B&W Photos.)

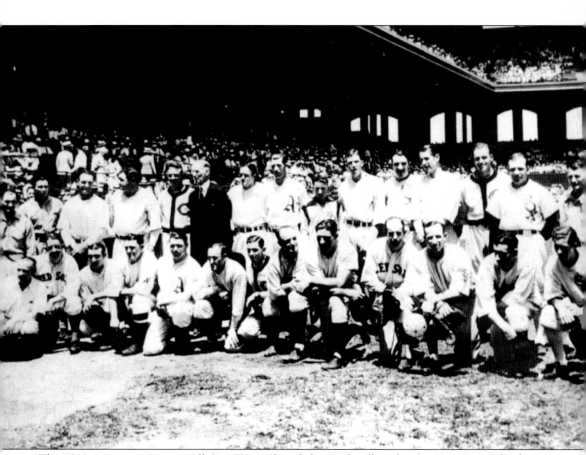

The 1933 American League All-Star Team, from left to right: (kneeling) trainer Doc Schacht, Eddie Collins, Tony Lazzeri, Al Crowder, Jimmy Foxx, coach Art Fletcher, Earl Averill, Ed Rommel, Ben Chapman, Rick Ferrell, Sam West, Charlie Gehringer, Clyde McBride, and the batboy; (standing) clubhouse man Art Colledge, batting practice catcher Bill Conroy, Lou Gehrig, Babe Ruth, Orv Hildebrandt, manager Connie Mack, Joe Cronin, Lefty Grove, batboy Harry Colledge, Bill Dickey, Al Simmons, Lefty Gomez, Wes Ferrell, Jimmy Dykes, and clubhouse man Eph Colledge. (Courtesy EHC, BHC, DPL.)

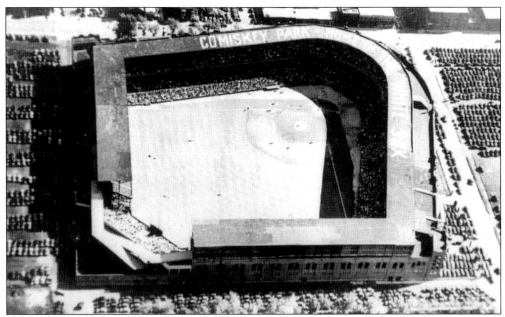

47,595 filled Comiskey Park on July 6, 1933. Babe Ruth's two-run homer helped the American League to a 4-2 victory. (Courtesy Ray Mediros.)

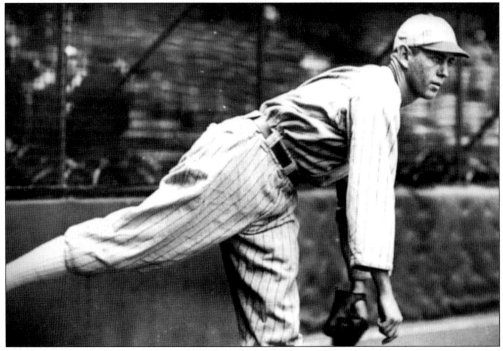

Ten years after he broke in with the White Sox, Ted Lyons lost 21 games as the Sox finished sixth in 1933. (Courtesy EHC, BHC, DPL.)

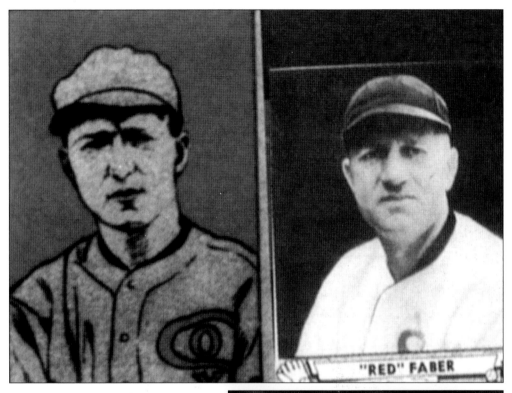

"RED" FABER

Above: Red Faber, who had pitched for the White Sox since 1914, wrapped up his 20-year big league career in 1933. Faber won 254 games and lost 212 while posting an ERA of 3.15. (Author's collection.)

Right: After 17 games in the 1934 season, Lew Fonseca was fired and third baseman Jimmy Dykes was given the managerial job. (Courtesy B&W Photos.)

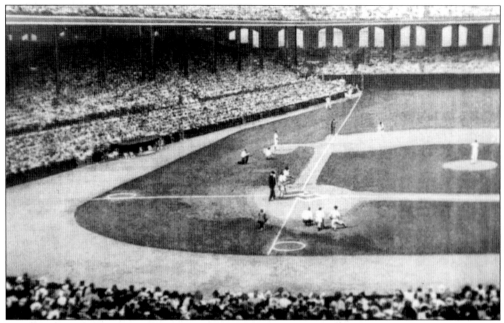

Home plate was moved 14 feet toward center field as the outfield distances were shortened in 1934. (Courtesy Ray Mediros.)

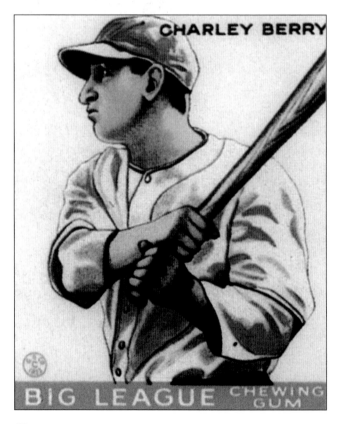

Catcher Charlie Berry, who hit .291 the season before, was no longer with the White Sox as he was traded to the Philadelphia Athletics. Berry, an All-American football player prior to making the big leagues, would become an American League umpire from 1942 to 1962. (Author's collection.)

Catcher Muddy Ruel wrapped up his 19 years in the big leagues with the White Sox in 1934 and posted a .275 career average. (Author's collection.)

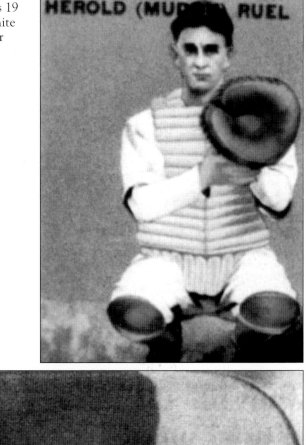

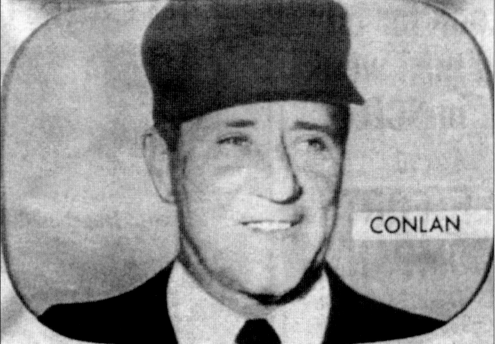

Reserve outfielder Jocko Conlan managed a two-year career in the big leagues with the White Sox (1934–1935) but never experienced hitting a home run while hitting .263. He became a Hall of Famer after becoming an umpire in the National League. (Courtesy Sy Berger.)

Left: After spending the last four seasons of his 22-year pitching career with the White Sox, "Sad" Sam Jones retired after the 1935 season with 229 wins, 217 losses, and an ERA of 3.84. Jones became president of Woodsfield Saving and Loan Association of Woodfield, Ohio. (Courtesy EHC, BHC, DPL.)

Below: Rabbit Maranville, who played shortstop for 23 years in the big leagues before retiring at 43 in 1935, offers some tips to shortstop Luke Appling, who represented the White Sox in the 1936 All-Star Game. (Courtesy B&W Photos.)

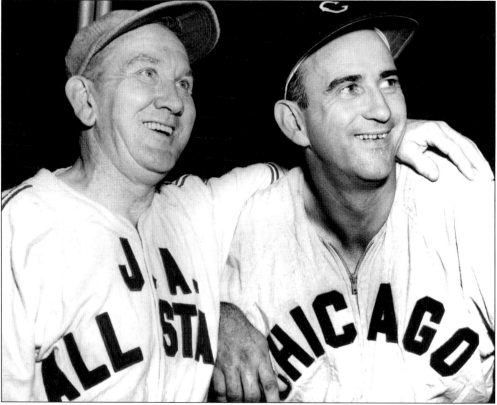

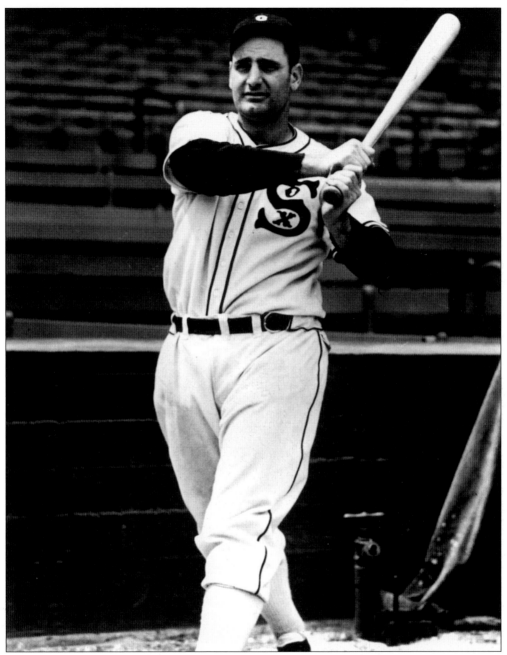

In 1936 first baseman Zeke Bonura hit .330 and drove in 138 runs, helping the White Sox to a third place finish, the highest since 1920. (Courtesy B&W Photos.)

Outfielder Mule Haas, who came to the White Sox in 1933, wrapped up his 12-year big league career with a .292 batting mark in 1937 as home plate was moved back to where it was prior to the '34 season.

Mervyn Connors played first, second, and third base for the White Sox in 1937–1938, but despite a .355 batting average in 62 at-bats in 1938, his big league career was over at the age of 24. (Courtesy EHC, BHC, DPL.)

The year 1938 was the first of catcher Mike Tresh's 11 seasons with the White Sox.

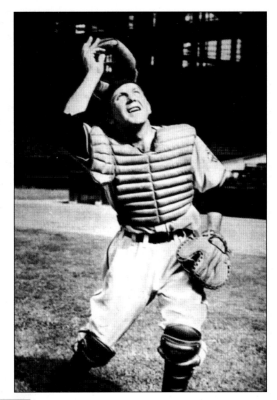

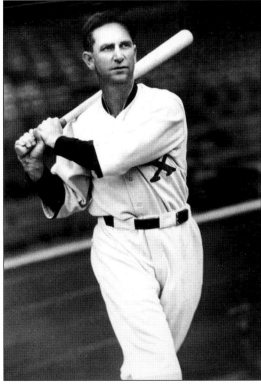

Outfielder Ray "Rip" Radcliffe spent seven seasons with the White Sox. He hit .335 in 1936, .325 in 1937, .330 in 1938, and after a .264 season in 1939, was traded. (Courtesy EHC, BHC, DPL.)

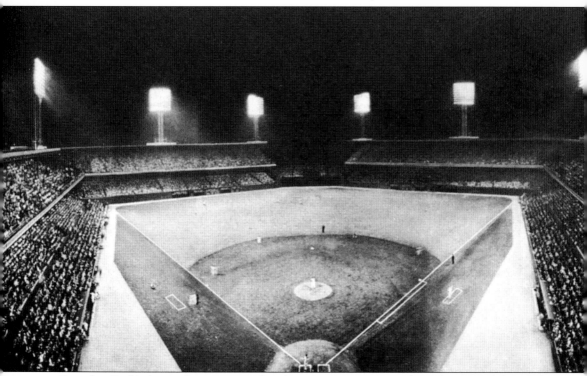

Comiskey Park's first night game was played on August 14, 1939. The White Sox defeated the St. Louis Browns, 5-2. (Courtesy Chicago White Sox.)

Infielder Eric McNair batted .324 for the White Sox in 1939 and dropped to .227 in 1940, leading to a trade. After his 14-year big league career, McNair stayed in the game as a minor league manager and scout for the Philadelphia Athletics.

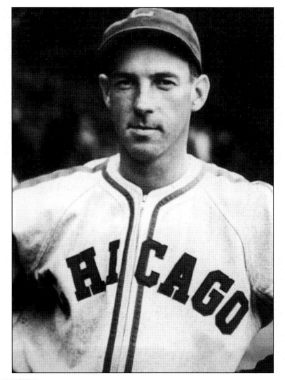

Outfielder Henry Steinbacher hit .331 in 1938 in 106 games for the White Sox, but dropped to .171 in 1939 and played himself out of the major leagues. He went on to a 23-year career as a police officer in Sacremento, California. (Courtesy EHC, BHC, DPL.)

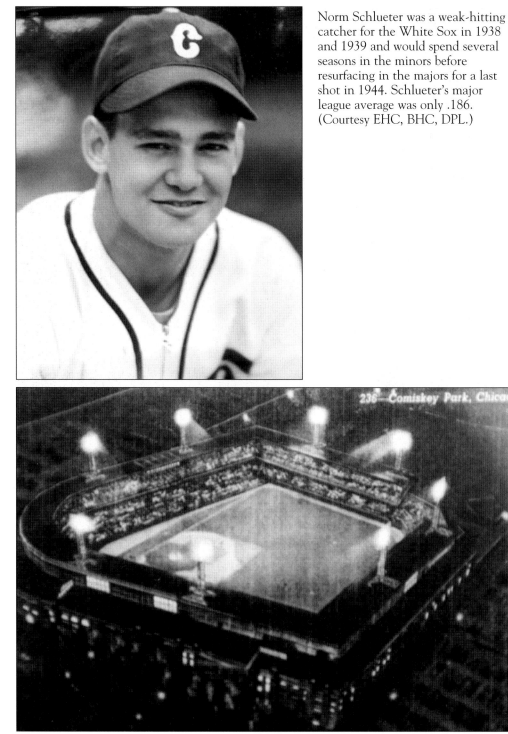

Norm Schlueter was a weak-hitting catcher for the White Sox in 1938 and 1939 and would spend several seasons in the minors before resurfacing in the majors for a last shot in 1944. Schlueter's major league average was only .186. (Courtesy EHC, BHC, DPL.)

After the death of Lou Comiskey in 1939, his widow, Grace, fought off attempts to sell the club by the First National Bank of Chicago and keep ownership under the Comiskey banner. (Author's collection.)

In 1940 popular shortstop Luke Appling had already played ten seasons with the White Sox and would go on to play another ten, all with the Sox. (Courtesy B & W Photos.)

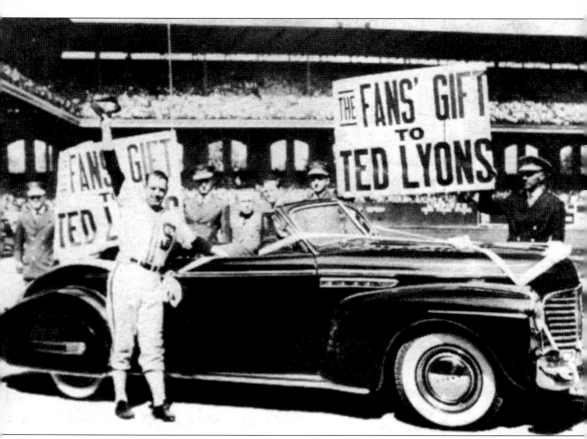

In appreciation for Ted Lyons, who was in his thirteenth season, September 15, 1940, was designated Ted Lyons Day at Comiskey Park. (Courtesy Chicago White Sox.)

Pitcher John Rigney's wife, Dorothy, was the daughter of team president Grace Comiskey. After his playing days with the White Sox ended in 1946, Rigney was put in charge of the White Sox farm system and went on to become vice president of the team. (Courtesy EHC, BHC, DPL.)

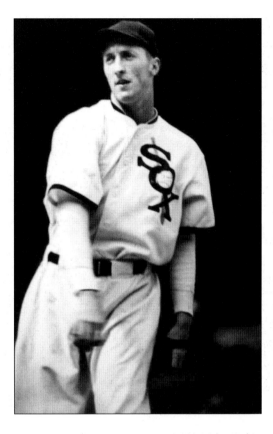

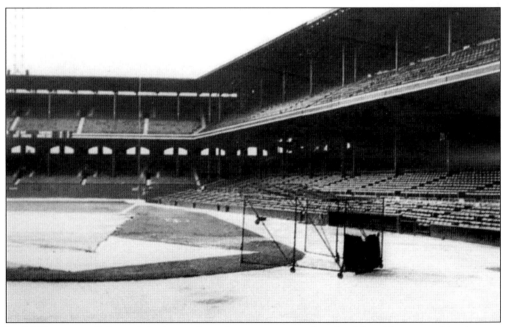

In 1941 many of the original grandstand seats were replaced with wider curved-back ones anchored to the concrete, causing a drop in seating capacity. (Courtesy Ray Mediros.)

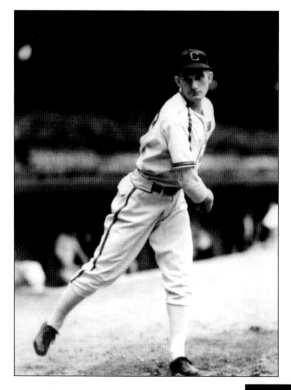

The White Sox had high hopes for tall pitcher Jack Hallett, but after two seasons of poor pitching, Hallett was traded late in 1941. After his mediocre career, Hallett became sales manager for an Ohio Buick dealership. (George Burke photo, courtesy EHC, BHC, DPL.)

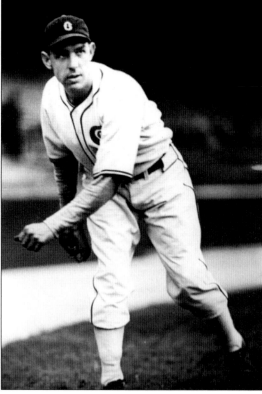

Thornton Lee, who pitched for the White Sox from 1937 to 1947 in a 16-year career, led the team in 1941 with 22 wins and the league in ERA with 2.37. (Courtesy EHC, BHC, DPL.)

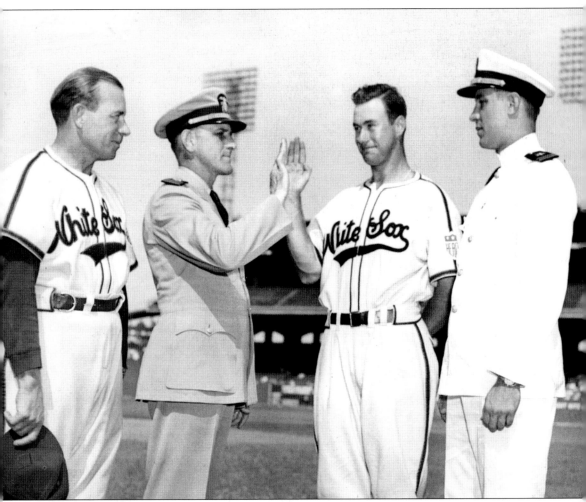

In 1942 the Star Spangled Banner was played before every game. Manager Jimmy Dykes (left) looks on as third baseman outfielder Bob Kennedy is inducted into the Navy between games of an August doubleheader. (Courtesy Acme, Chicago Promotions.)

After finishing fourth, seventh, and sixth the previous three seasons, the White Sox made a managerial change on May 24, 1946, after 12 seasons under Jimmy Dykes. Ted Lyons took over the club in seventh place and guided the Sox to fifth place. In 1946 Comiskey Park had its highest attendance since it opened: 983,403. (Courtesy Ray Mediros.)

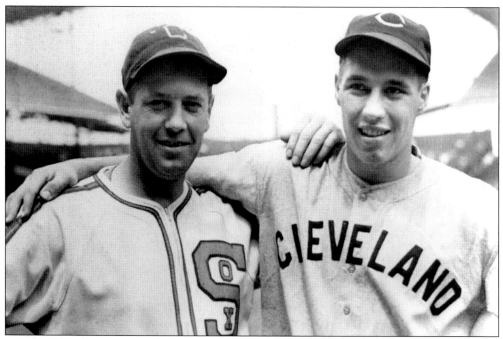

Ted Lyons, who pitched for mostly second division White Sox clubs after 1923 and went on to win 260 games by the time he became full-time manager, often shared tips with Cleveland star Bob Feller. (Courtesy B&W Photos.)

After a 70-84 sixth place finish in 1947 and skidding to last place (51-101) in 1948, Lyons was released. (Courtesy Ray Mediros.)

There were changes in the front office in 1948 as Chuck Comiskey (grandson of Charles) was appointed team vice president and Frank Lane (right) became General Manager. (Courtesy Don Unferth, Chicago White Sox.)

Because of new seating installed in 1941 and 1947, Comiskey Park's seating capacity was reduced to 44,492.

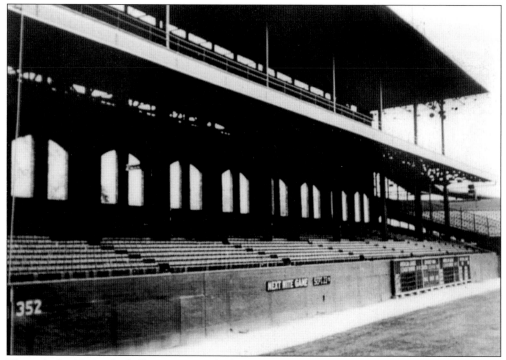

Through the 1940s, the bullpens were in the left and right field foul areas. (Courtesy Ray Mediros.)

1949 marked Billy Pierce's first year with the White Sox. Pierce would win 211 games over an 18-year career. (Courtesy EHC, BHC, DPL.)

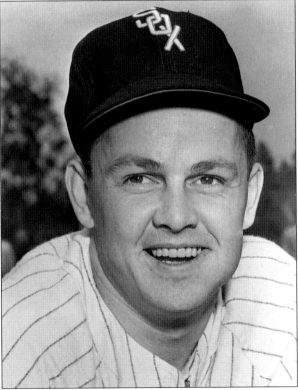

Second baseman Nelson Fox was another of Frank "Trader" Lane's newcomers in 1949. (Courtesy Sports Legends Photos.)

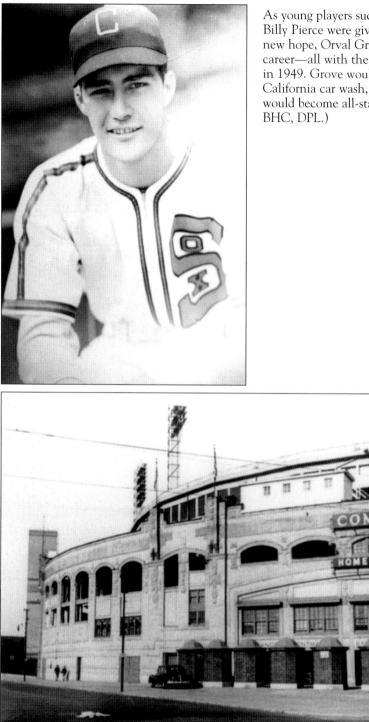

As young players such as Nelson Fox and Billy Pierce were giving White Sox fans new hope, Orval Grove's 10-year pitching career—all with the White Sox—was over in 1949. Grove would own and operate a California car wash, while Fox and Pierce would become all-stars. (Courtesy EHC, BHC, DPL.)

Even though a poor 63-91 record put the team in sixth in 1949, under manager Jack Onslow, 937,151 paid their way into Comiskey Park. (Courtesy Ray Mediros.)

Infielder Cass Michaels, who hit .308 in his seventh White Sox season in 1949, was hitting .312 after 36 games into the 1950 season when he was traded to Washington. (Courtesy B&W Photos.)

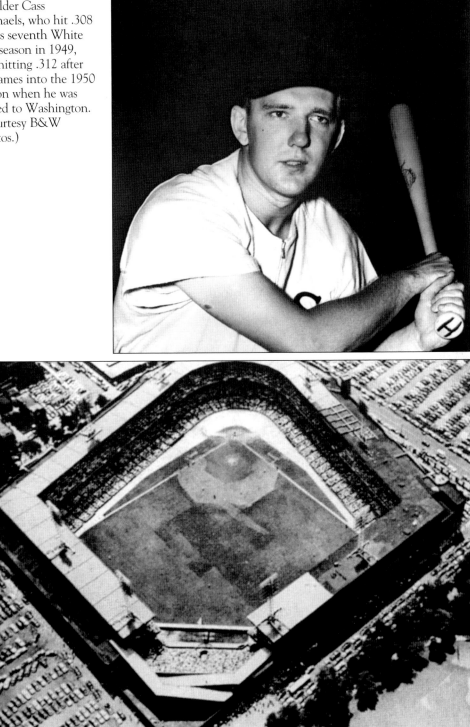

Comiskey Park hosted the 1950 All-Star Game before a crowd of 46,127. The National League defeated the American League, 4-3, in 14 innings. (Courtesy Don Unferth, Chicago White Sox.)

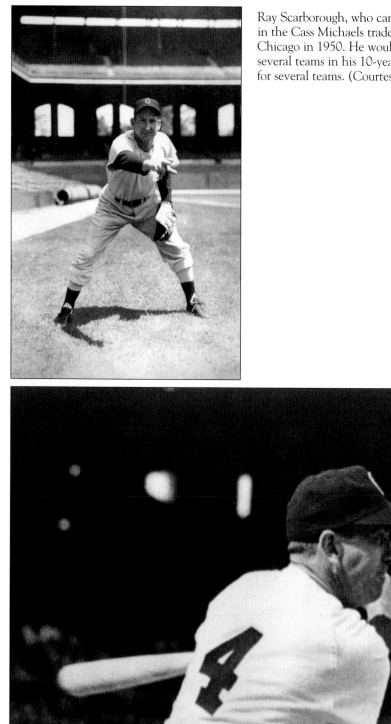

Ray Scarborough, who came to the White Sox in the Cass Michaels trade, won ten games for Chicago in 1950. He would go on to pitch for several teams in his 10-year career and to scout for several teams. (Courtesy EHC, BHC, DPL.)

Luke Appling, who hit over .300 in 16 of his 20 years with the White Sox, only saw action in 50 games in 1950 and retired with a .310 career average. Appling would serve as a coach, manager, and batting instructor for several teams. (Courtesy Sports Legends Photos.)

Alfonso Chico Carrasquel made his debut with the White Sox in 1950, and the slick-fielding shortstop played in 144 games and batted .282. (Courtesy Sports Legends Photos.)

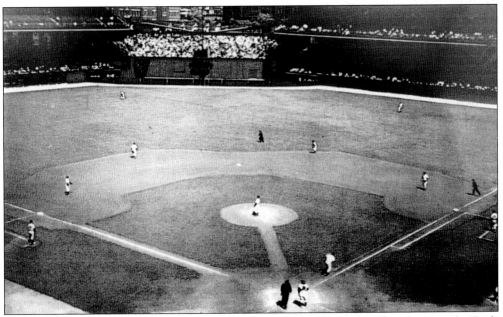

In 1950, with the team at 8-22, manager Jack Onslow was fired and replaced with "Red" Corriden. The latter's Sox record was 52-72 and the team ended in sixth. Paul Richards took over as manager in 1951. (Courtesy Ray Mediros.)

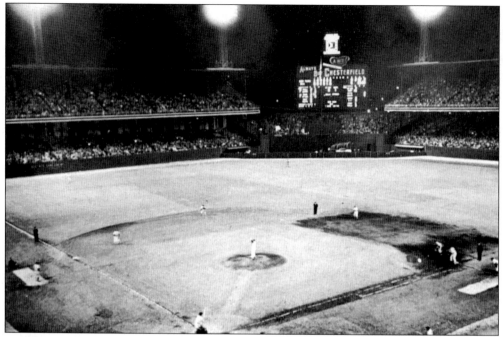

A night game with the Yankees on June 8, 1951, set a night Comiskey Park attendance record of 53,940. The same year also saw the installation of the first electric scoreboard. (Courtesy Don Unferth, Chicago White Sox.)

Randy Gumpert's best season was 1946 when he posted an 11-3, 2.31 ERA for the Yankees. Sold to the White Sox in 1948, Gumpert's last season with the Sox was in 1951 when he won nine games. (Courtesy B&W Photos.)

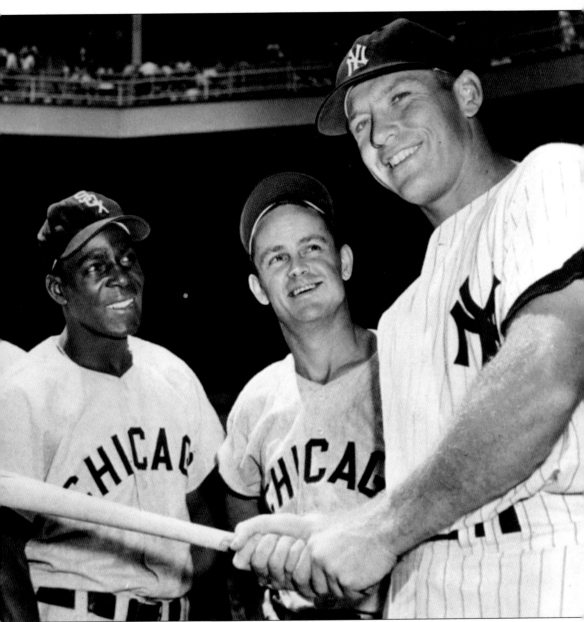

Traded in the 1951 season to the White Sox, Minnie Minoso became the franchise's first black player and homered in his first game. In the same game, rookie Mickey Mantle collected his very first big league round-tripper. Nelson Fox (center) admires Mantle's strength. (Courtesy B&W Photos.)

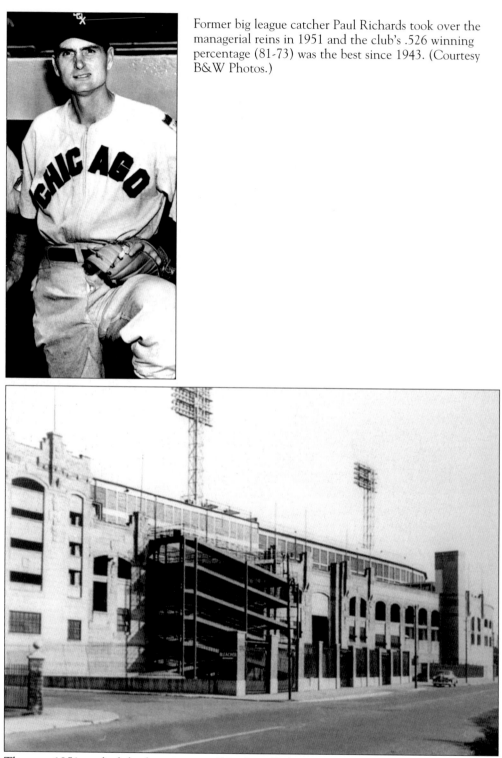

Former big league catcher Paul Richards took over the managerial reins in 1951 and the club's .526 winning percentage (81-73) was the best since 1943. (Courtesy B&W Photos.)

The year 1951 marked the first time a million fans filed into Comiskey Park as the fourth place White Sox drew 1,328,234. (Courtesy Ray Mediros.)

In his seventh big league season, catcher Sherm Lollar came to the White Sox in 1952 and would be with the team until 1963. (Courtesy Don Unferth, Chicago White Sox.)

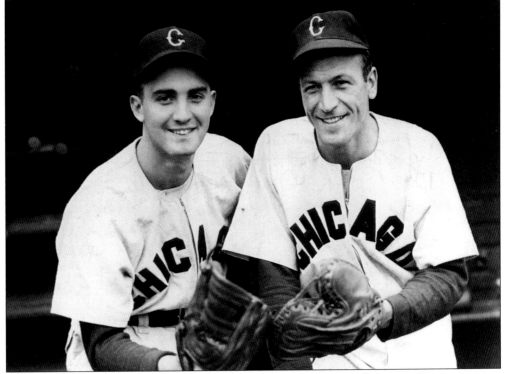

Billy Pierce (left) was a young veteran of 25 in 1952 when catcher Phil Masi, 35, was wrapping up his 14-year big league career. (Courtesy B&W Photos.)

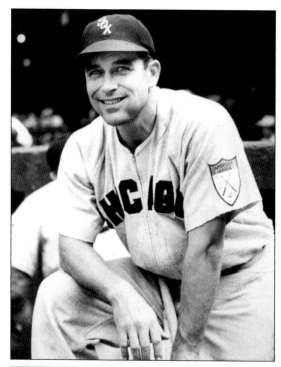

First baseman Eddie Robinson hit .282 with 29 home runs and 117 RBIs in 1951, and .296 with 22 homers and 104 RBIs in 1952. Robinson was dealt to the Philadelphia Athletics as the trade brought first baseman Ferris Fain, who had won the American League batting title the past two years, to Chicago. (Courtesy EHC, BHC, DPL.)

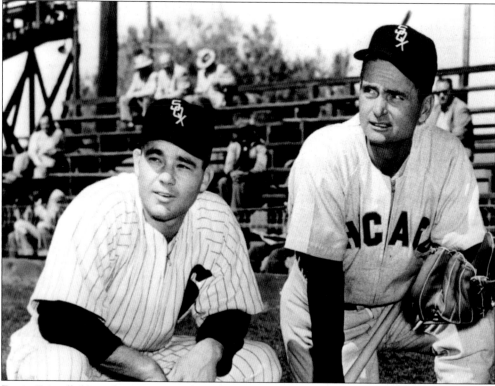

Ferris Fain (left) and manager Paul Richards ponder the future prior to the 1953 season. (Courtesy B&W Photos.)

After posting good marks of 14-9, 3.85 ERA in 1952, Saul Rogovin slipped to 7-12, 5.22 in 1953 and was sent packing. After his career ended, Rogovin went back to college and became a public school teacher in his native New York.

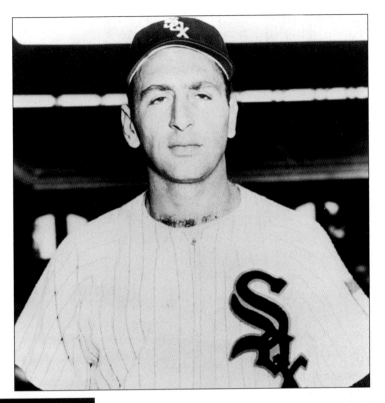

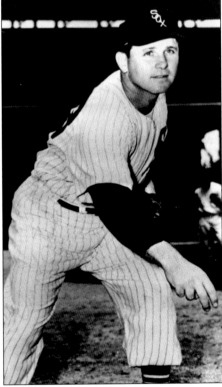

Virgil Trucks pitched two no-hitters and one one-hitter for the Detroit Tigers in 1952 but lost 19 games. After coming to the White Sox in 1953, Trucks racked up 20 wins for the season. (Courtesy B&W Photos.)

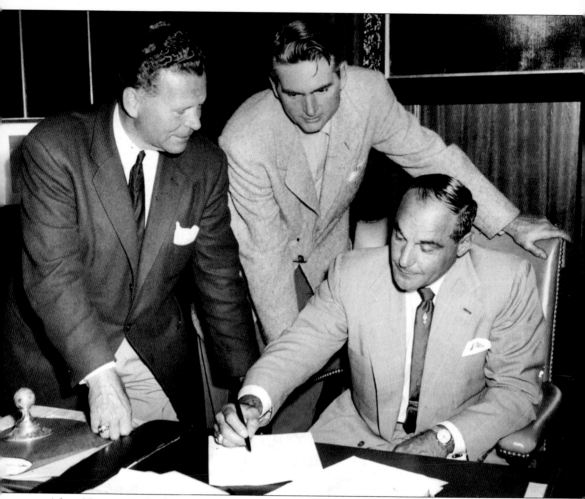

After 20 years with the Cubs as a player and a couple of seasons as player-manager, Phil Cavaretta moved south and signed on with the White Sox as a pinch-hitter and utility first baseman. Pictured from left to right are general manager Frank Lane, manager Paul Richards, and Cavaretta. In 156 at-bats in 1954, Cavaretta batted .316. (Courtesy Chicago Promotions.)

Former National League shortstop Marty Marion, who managed the St. Louis Cardinals and St. Louis Browns, took over as White Sox manager when Paul Richards resigned late in the 1954 season to accept a position with the Baltimore Orioles. (Courtesy Don Unferth, Chicago White Sox.)

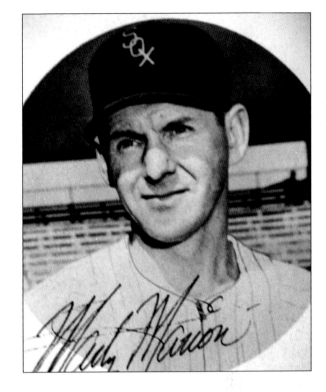

Big (6' 5") first baseman Walt Dropo batted .322 with 34 home runs as a rookie 1950 but skidded to a .239 average and only 11 home runs the following season. Traded to Detroit and then Chicago, Dropo captured some of the magic for the Chisox in 1955 by hitting 19 homers and batting .280. (Courtesy EHC, BHC, DPL.)

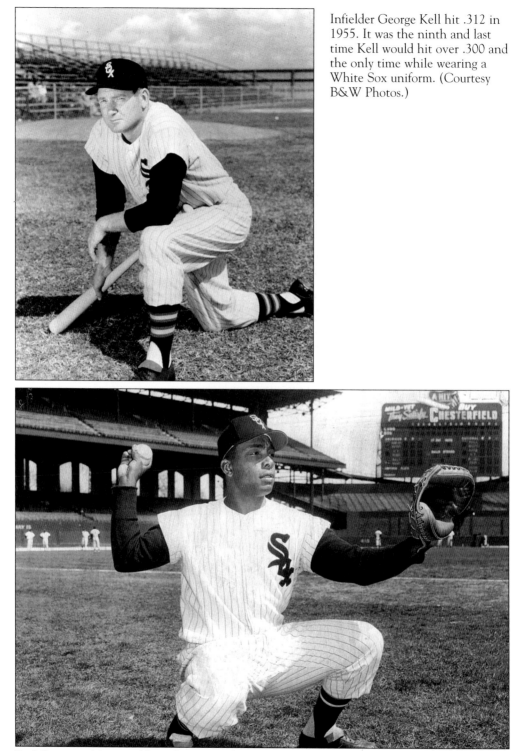

Infielder George Kell hit .312 in 1955. It was the ninth and last time Kell would hit over .300 and the only time while wearing a White Sox uniform. (Courtesy B&W Photos.)

Earl Battey, a 20-year-old catcher, began his 13-year big league career with the White Sox in 1955. (Courtesy Chicago Promotions.)

After almost ten years with the Reds, veteran infielder Bobby Adams was a member of the White Sox for 28 games in 1955 and batted .095 before moving on to two more clubs. (Courtesy B&W Photos.)

In his eleventh big league season, Ellis Kinder was traded to the White Sox in 1956. His first win that season was career victory number 100. (Courtesy Don Unferth, Chicago White Sox.)

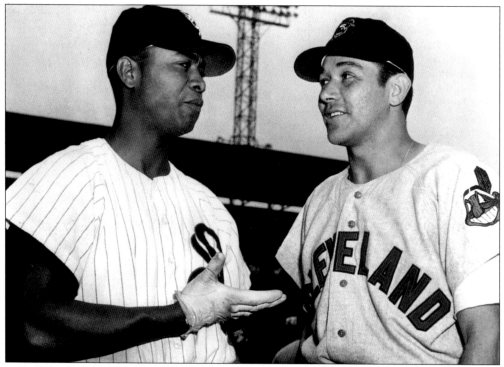

Larry Doby (left) and Chico Carrasquel switch uniforms. Doby, who broke the color barrier in the American League when he made his debut in Comiskey Park while playing for the Cleveland Indians on July 5, 1947, joined the White Sox in a trade for Carrasquel. (Courtesy B&W Photos.)

Speedy Luis Aparicio became the new starting shortstop for the White Sox in 1956, the first of 18 seasons in the major leagues. (Courtesy B&W Photos.)

Outfielder Dave Philley broke in with the White Sox in 1941 and went on to play with other clubs. Philley was dealt back to the Sox during the 1956 season and delivered some key hits, helping the club to a third place finish. It was the fifth consecutive third place finish for the Chisox. (Courtesy Don Unferth, Chicago White Sox.)

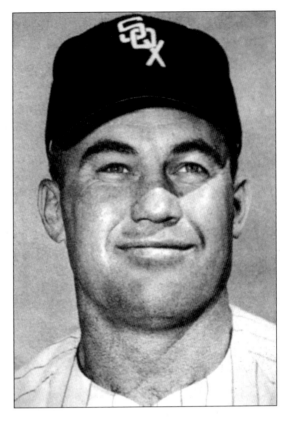

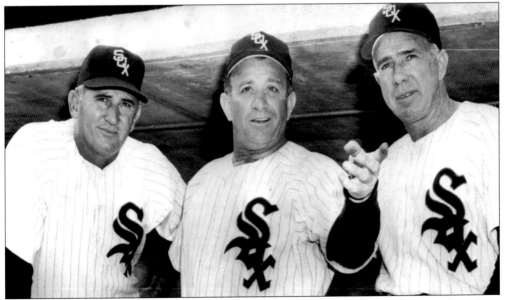

Pictured from left to right are new White Sox manager Al Lopez and two of his coaches, Tony Cuccinello and Johnny Cooney, in 1957. The three were teammates with Boston and Brooklyn in the 1930s, and the White Sox were the fifth club Lopez and Cuccinello were paired up with. (Courtesy collection of Dennis Jose, Chicago Sports Promotions.)

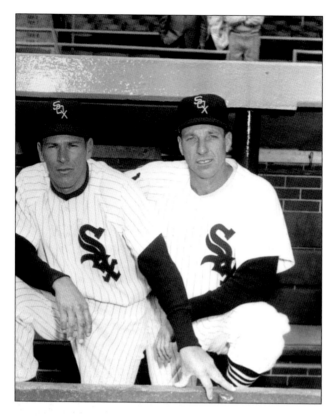

Veteran infielder Billy Goodman (left) and pitcher Gerry Staley helped the White Sox to a second consecutive second place finish in 1958. (Courtesy B&W Photos.)

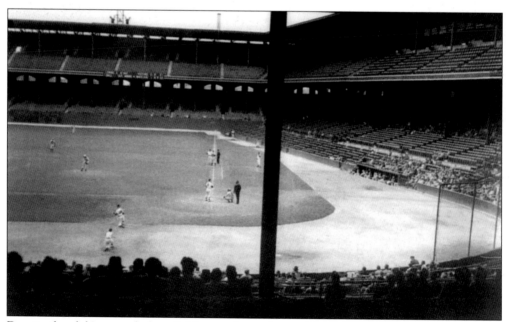

Despite the club's second-place finish attendance dropped by 338,217 to only 797,451 in 1958. (Courtesy Ray Mediros.)

FIVE
A New Era

Chicago's star shortstops of the 1950s: Luis Aparicio (left) of the White Sox and Ernie Banks of the Cubs. (Courtesy B&W Photos.)

Prior to the 1959 season, Bill Veeck and his partners gained majority control of the White Sox over the Comiskey heirs. The year 1959 would be the first season the White Sox would not be under the direction of a Comiskey. (Courtesy Don Unferth, Chicago White Sox.)

Under Bill Veeck's ownership, the Bards Room opened by Charles Comiskey in the old ballpark became a crowded and lively gathering spot. (Courtesy Ray Mediros.)

After two second place finishes, manager Al Lopez (seated in the first row, sixth from left) led the White Sox to the pennant, the franchise's first since 1919. (Courtesy Sports Legends Photos.)

Pitcher Barry Latman appeared in 37 games in 1959 and won eight games. Latman didn't see action in the World Series and would spend the next seven seasons with four different clubs. (Courtesy B&W Photos.)

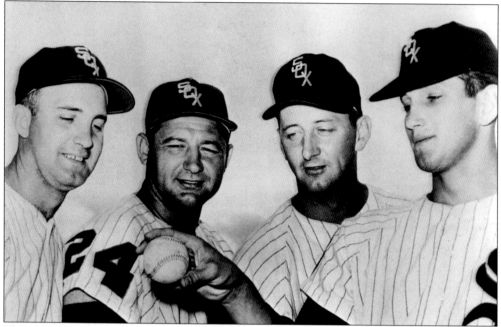

The 1959 White Sox pitching staff included Billy Pierce (left),who won 14 games, while Early Wynn led the league in victories with 22. Dick Donovan accounted for nine wins and Barry Latman (holding the ball) eight. (Courtesy B&W Photos.)

Veteran slugging first baseman Ted Kluszewski came to the White Sox from the National League late in the 1959 season, saw action in 31 games, and batted .297. In the World Series, Big Klu starred by batting .391 with three home runs and 10 runs batted in. (Courtesy B&W Photos.)

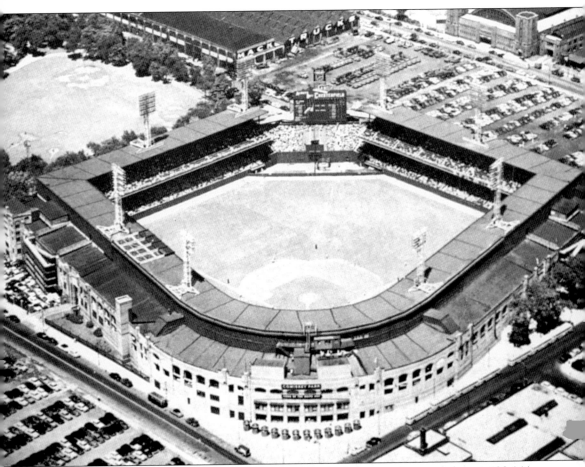

In 1959 the pennant-winning White Sox drew their highest attendance to date, 1,423,144. Attendance increased in 1960 to 1,644,460 even though the club dropped to third place, ten games behind the first-place Yankees. (Courtesy Bill Veeck, Chicago White Sox.)

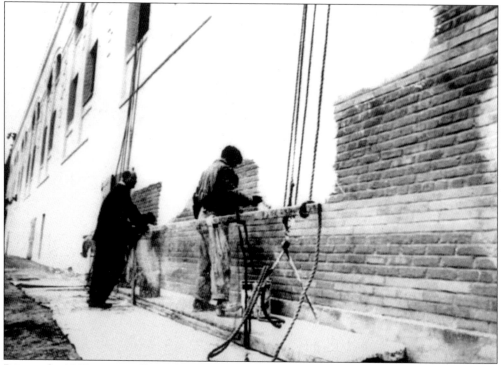

Prior to the 1960 season, Bill Veeck supervised the whitewashing of the exterior of Comiskey Park.

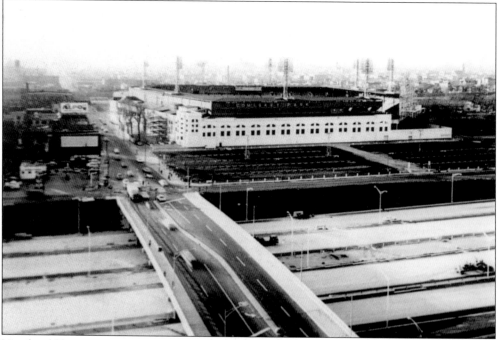

Veeck sold his majority interest in the club because of ill health in the summer of 1961, but left his mark on Comiskey Park by installing an exploding scoreboard and left field picnic area. (Courtesy Ray Mediros.)

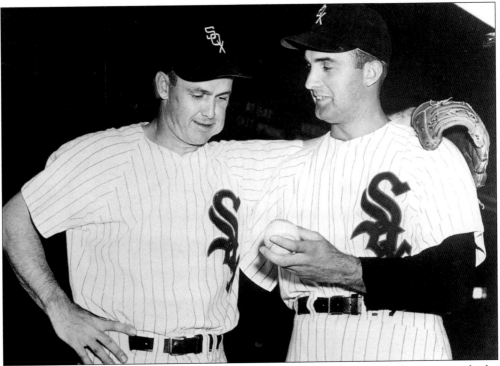

Nellie Fox (left) said goodbye to Billy Pierce after the 1961 season. In 13 seasons with the White Sox, Pierce won 186 games. (Courtesy B&W Photos.)

Popular outfielder Manuel Joseph Rivera, known to fans as "Jungle Jim," came to the White Sox in 1952 and stayed until 1961. (Courtesy B&W Photos.)

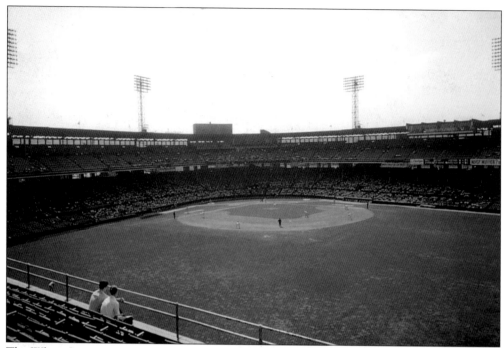

The White Sox won 86 games in 1961, only good enough for fourth place, 23 games shy of the pace set by the power-hitting Yankees.

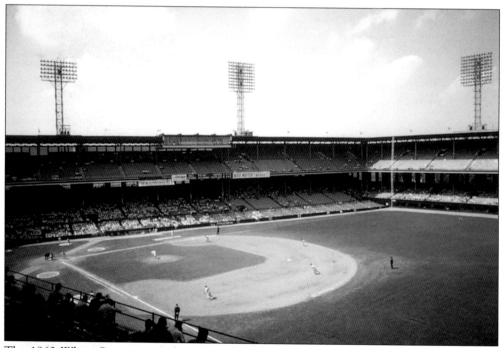

The 1962 White Sox won one less game than the previous year and dropped to fifth place. (Photos by author.)

Above: The great seven-year double play combination of shortstop Luis Aparicio (left), and second baseman Nellie Fox was broken up when Aparicio was traded to Baltimore before the 1963 season. Fox, who spent 14 seasons with the White Sox, was traded to Houston after the '63 season. (Courtesy B&W Photos.)

Right: Dave DeBusschere was a two-sport star in college. He pitched for the White Sox in 1962 and 1963, compiling a low ERA of 2.90 while playing basketball for the Detroit Pistons in the off season. In 1964 he opted for basketball and became the youngest coach in NBA history at the age of 24. (Courtesy Chicago White Sox.)

The excitement returned to Comiskey Park in 1963 as the club finished second and won 94 games. (Courtesy Ray Mediros.)

The White Sox had high hopes for slugging outfielder Dave Nicholson, who hit 22 homers in 1963. (Courtesy B&W Photos.)

In 1964 Nicholson hit three home runs in one game. One of the homers cleared the left field roof; the blast was estimated at 573 feet. Nicholson only totaled 13 home runs and batted .204 in '64. (Courtesy Chicago White Sox.)

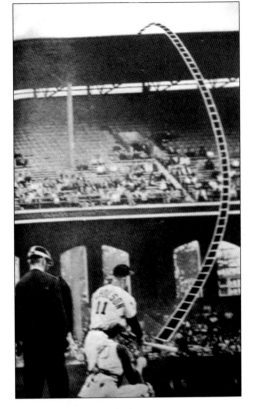

One of the most popular White Sox players of all time, Cuban-born Orestes "Minnie" Minoso was brought back for the third time in his 16 years. He only batted .226 in 31 at-bats and was released. (Courtesy George Brace.)

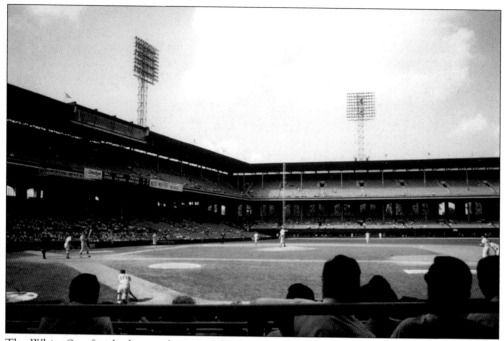

The White Sox finished second in 1965 for the third consecutive season. (Photo by author.)

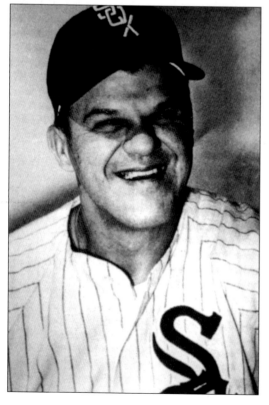

Chicagoan Bill Skowron, who broke into the big leagues as a first baseman with the Yankees in 1954, was traded to the White Sox in mid-season ten years later. In his first full year with Chicago in 1965, Skowron batted .274 with 18 home runs in 146 games. (Courtesy Don Unferth, Chicago White Sox.)

Because of health problems, manager Al Lopez, who had led the Sox since 1957, resigned after the 1965 season. (UPI Photo Courtesy Chicago Promotions.)

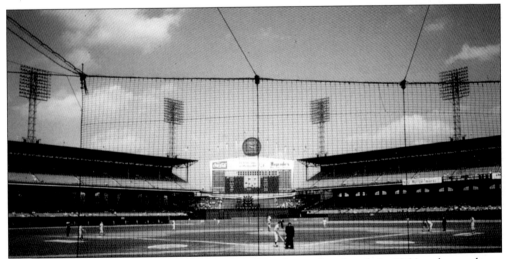

Under new manager Eddie Stanky, the White Sox dropped to fourth in 1966 and attendance dipped under a million for the first time in the decade. (Photo by author.)

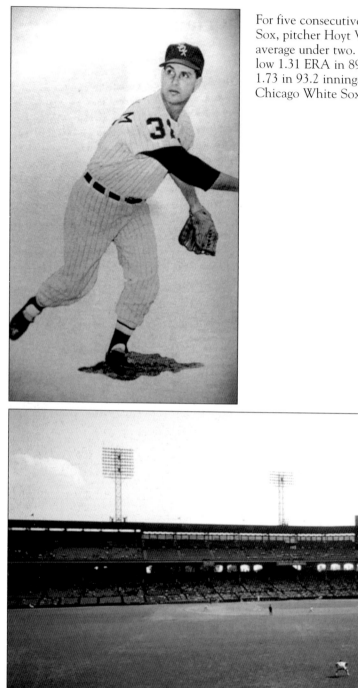

For five consecutive seasons with the White Sox, pitcher Hoyt Wilhelm had an earned run average under two. In 1967 Wilhelm posted a low 1.31 ERA in 89 innings and in 1968, a 1.73 in 93.2 innings. (Courtesy Don Unferth, Chicago White Sox.)

After two fourth-place finishes under Eddie Stanky, the White Sox changed managers in the 1968 season. Les Moss and the returning Al Lopez took their turns, but the trio couldn't stop the club from falling to a tie for eighth. (Photo by author.)

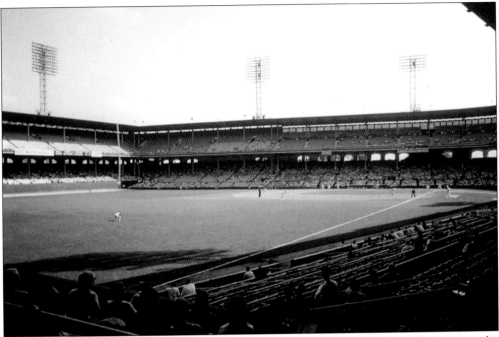

Another change was the installation of artificial turf in the infield for the 1969 season as the outfield grass still remained.

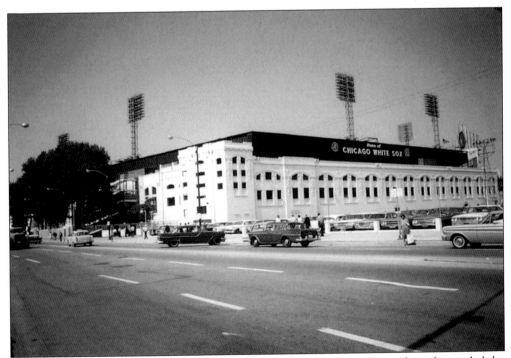

Manager Al Lopez decided to leave again and was replaced by Don Gutteridge, who guided the team to fifth. (Photo by author.)

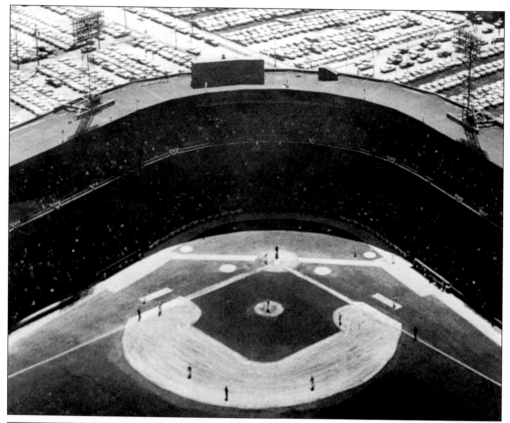

Above: The 1970 season began with a new owner since Arthur Allyn, Jr., sold the club to his brother, John, the previous September. Management hired three managers—Don Gutteridge, Bill Adair, and Chuck Tanner, as the team managed to lose 106 games to set a franchise record, and only 495,355 fans paid their way into the park.

Left: In his first full season as White Sox manager, Chuck Tanner guided the club to a 23-game improvement, good enough for third place. (Courtesy Chicago White Sox.)

Long-time Cardinals play-by-play man Harry
Caray became the voice of the White Sox in 1971.
(Photo by author.)

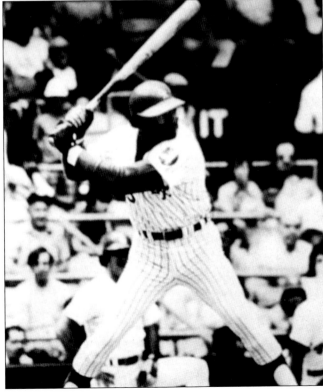

Traded to the White Sox in
1972, first baseman Dick Allen
led the league in home runs
with 37 and RBIs with 113. It
was a good year for the south-
siders as the club improved to
second place and drew over a
million fans. (Courtesy
Chicago White Sox.)

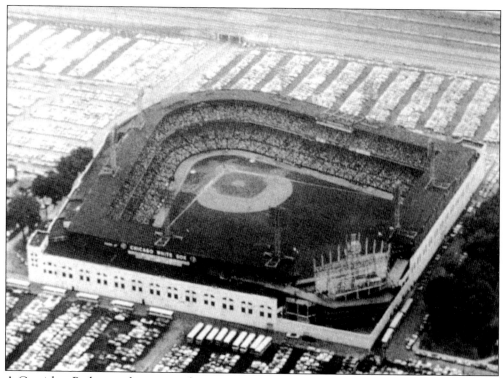

A Comiskey Park attendance record was set on May 20, 1973, when 55,555 paid their way into the ballpark for the Sunday doubleheader. (Courtesy Chicago White Sox.)

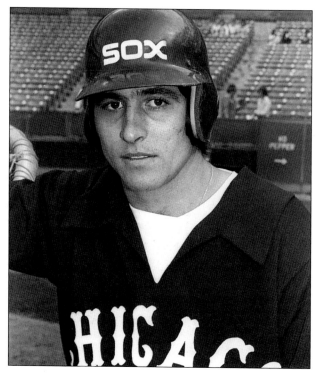

The year 1973 was shortstop Bucky Dent's first of four seasons with the White Sox. The club lost ten more games in '73 than the previous season and finished fifth. (Courtesy B&W Photos.)

In 1974 Wilbur Wood had his fourth consecutive 20-victory season, helping the White Sox to 80 wins and fourth place. (Courtesy Chicago White Sox.)

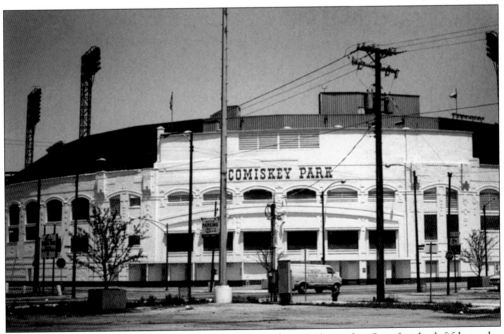

In 1975 only 770,800 paid their way into Comiskey Park as the Sox finished fifth under manager Chuck Tanner. (Photo by author.)

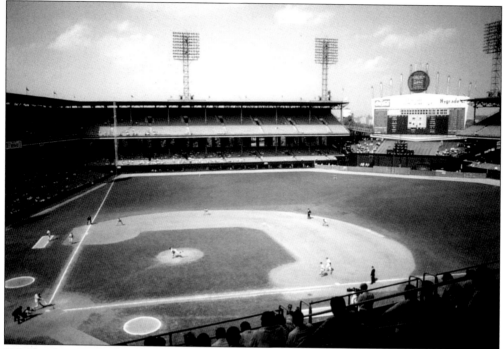

Bill Veeck came back as owner at the end of 1975 and replaced the infield turf with grass. However, the White Sox dropped to sixth, winning only 64 games. Attendance meanwhile edged upward to 914,945. (Photo by author.)

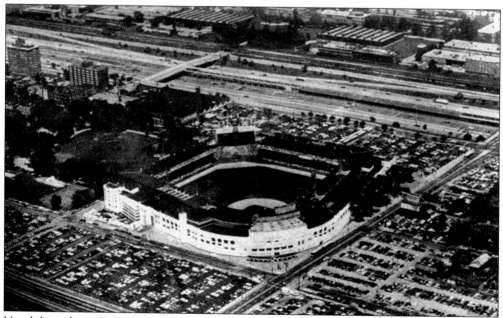

Veeck brought in Bob Lemon to manage in 1977 and the club won 90 games, finishing third. The Sox set an all-time Comiskey Park home attendance record of 1,657,135, averaging 22,394 for each home date. (Courtesy Don Unferth, Chicago White Sox.)

In 1978 Larry Doby became baseball's second black manager. White Sox owner Bill Veeck had owned the Indians in 1947 and signed Doby in that year as the American League's first black player.

Pitcher Steve Stone won 12 and lost 12 for the 1978 fifth place White Sox, who won 71 games. Two years later he would win 25 games for the Baltimore Orioles, but would gain more fans as a color commentator for televised Cubs games. (Courtesy Don Unferth, Chicago White Sox.)

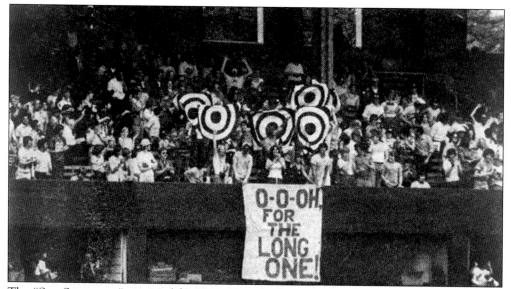

The "Sox Supporters" occupied $2.00 seats in the lower left field grandstand. Using a drum, bull's-eye targets, and some 50 canvas banners stored in the club's first aid room, the enthusiastic group reacted by producing a huge eye chart whenever an umpire's decision went against the home team. Targets were held high when slugger Richie Zisk came to bat, and when Jim Spencer stepped to the plate, there were banners stating: "Come on Spence. Over the Fence." (Courtesy Don Unferth, Chicago White Sox.)

Shortstop Don Kessinger was tagged as manager in 1979. Kessinger had the club in fifth place (46-60) after 106 games, participated in 56 games as a player, and was batting .200 when released from both positions. (Photo by Tony Inzerillo, Baseball Bulletin.)

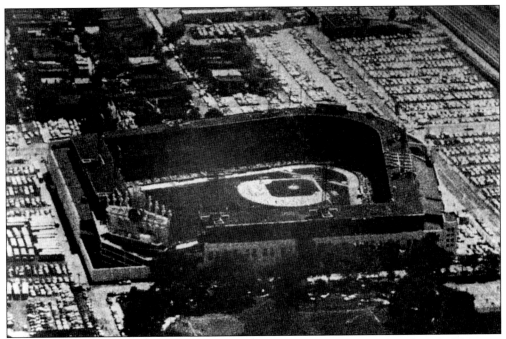

Tony LaRussa took over for Kessinger, and the Sox finished fifth in 1979 and 1980. (Courtesy Don Unferth, Chicago White Sox.)

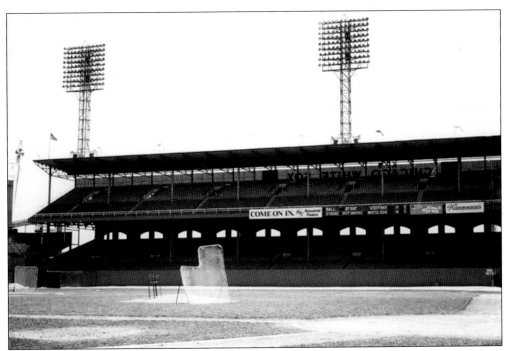

In 1981, for the fourth consecutive year, the club finished fifth and attendance dipped under a million for the first time in five seasons. (Photo by author.)

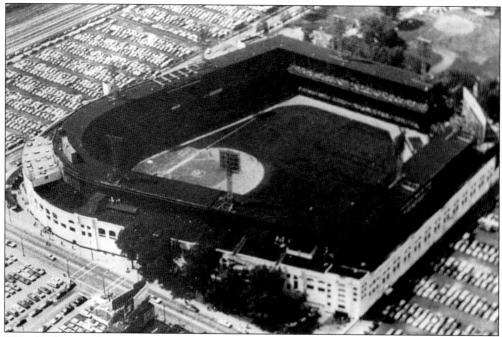

Eddie Einhorn and Jerry Reinsdorf purchased the club from Bill Veeck in 1981, and the following year the White Sox improved to third place and drew 1,567,787. (Courtesy Chicago White Sox.)

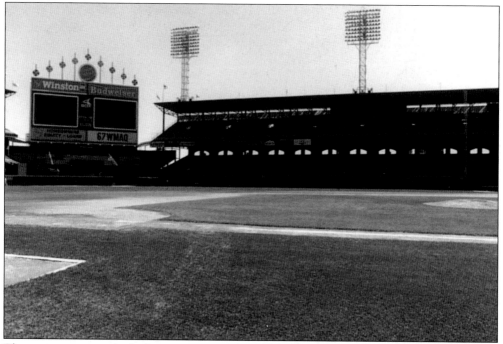

The new owners embarked on improving the old ballpark. New contour plastic seats were installed between the bases, and a state-of-the-art Diamond Vision scoreboard replaced the original monster in 1982. (Author's collection.)

Six
The Final Years

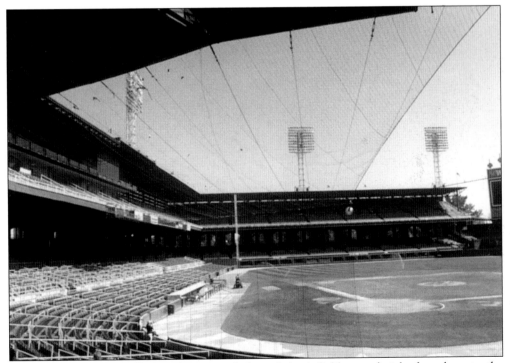

Luxury suites were installed in the upper deck, and the infield moved eight feet closer to the walls prior to the 1983 season. (Author's collection.)

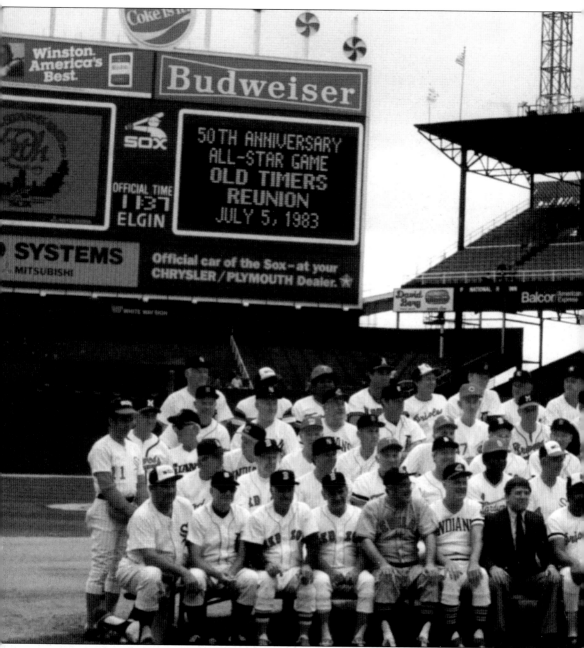

Comiskey Park hosted the 1983 All-Star Game, and celebrated the first one held in Comiskey 50 years earlier, by inviting 88 former stars and 13 of the living participants from the 1933 All-Star Game. Picture, from left to right, are: (first row) Early Wynn, George Kell, Bobby Doerr, Frank Malzone, Lou Boudreau, Kenny Keltner, White Sox president Eddie Einhorn, Frank Robinson, Joe Cronin, Waite Hoyt, Joe Sewell, Ben Chapman, Bill Dickey, Lefty Gomez, Edd Roush, Burleigh Grimes, Dick Bartell, Johnny Mize, and Judy Johnson; (second row) Pee Wee Reese, Rick Ferrell, Bobby Richardson, Harmon Killebrew, Al Kaline, Lou Brock, Luke Appling, Smoky Burgess, Billy WIlllams, Ron Santo, Del Crandall, Bobby Thomson, Leo Durocher, Billy Herman, Joe Torre, Willie Mays, and Wally Berger; (third row) Luis Aparicio, Warren Spahn,

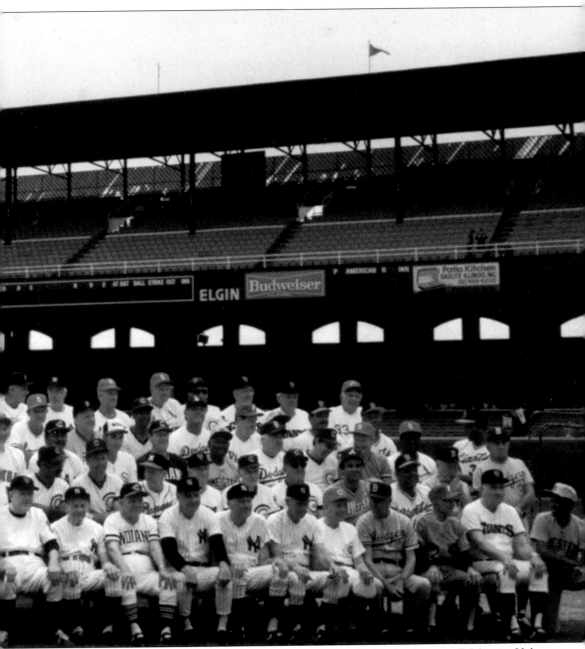

Carl Hubbell, Earl Averill, Sam West, Charlie Gehringer, Billy Pierce, Dominic DiMaggio, Hal Newhouser, Mickey Vernon, Larry Doby, Hoyt Wilhelm, Bob Feller, Buck Leonard, Duke Snider, Don Kessinger, Red Schoendienst, Bob Gibson, and Tony Cuccinello; (fourth row) Harvey Kuenn, Whitey Ford, Bob Lemon, Bill Freehan, Ewell Blackwell, Eddie Mathews, Bill Mazeroski, Stan Musial, Ralph Kiner, Ernie Banks, Don Drysdale, Robin Roberts, Cool Papa Bell, Juan Marichal, Monte Irvin, and Orlando Cepeda; (fifth row) Don Larsen, Minnie Minso, Tony Oliva, Jim Fregosi, Brooks Robinson, Jim Bunning, Bill Skowron, Roger Maris, Hank Greenberg, Joe DiMaggio, Enos Slaughter, Walker Cooper, Phil Cavarretta, Hal Schumacher, Travis Jackson, and Johnny Vander Meer. (Photo by author)

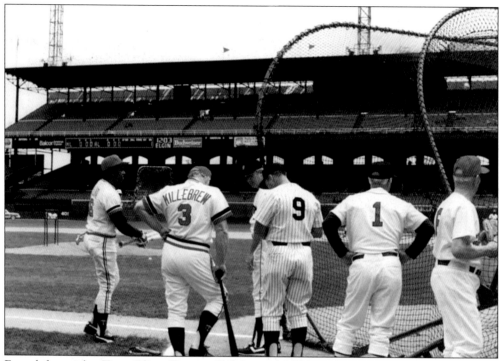

From left to right, Tony Oliva, Harmon Killebrew, A1 Kaline, Roger Maris, Bobby Doerr, and Sam West limber up for the Old-Timers All-Star Game held a day before the current stars played.

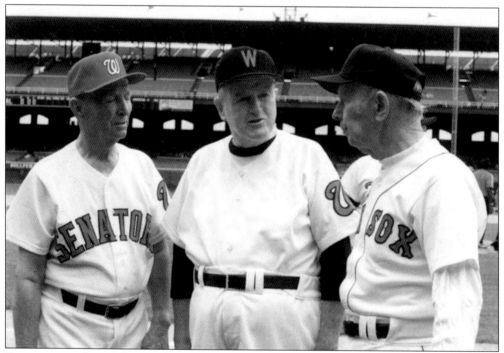

Former stars, from left to right, Sam West, Joe Cronin, and Rick Ferrell played for the American League All-Stars 50 years earlier. (Photos by author.)

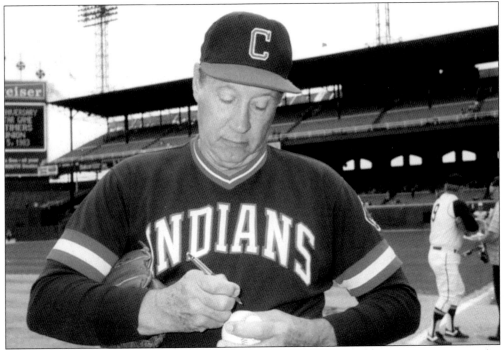

Bob Feller had many Comiskey Park memories, including pitching a no-hitter on opening day against the White Sox in 1940.

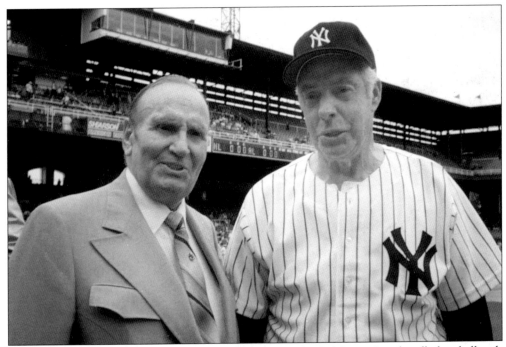

Legendary cowboy star Gene Autry, who went on to own the California Angels, talks baseball with old friend Joe DiMaggio prior to the 1983 All-Star festivities at Comiskey Park. (Photos by author.)

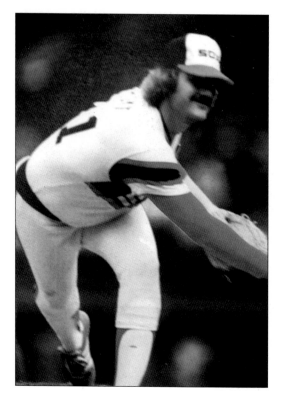

The White Sox, with 99 victories, won the American League Western Division title in 1983, and LaMarr Hoyt led the league with 24 wins. (Courtesy Chicago White Sox.)

Ron Kittle homered before the hometown crowd in the All-Star Game, hit 35 home runs with 100 RBIs in the regular season, and earned Rookie of the Year honors. (Courtesy B&W Photos.)

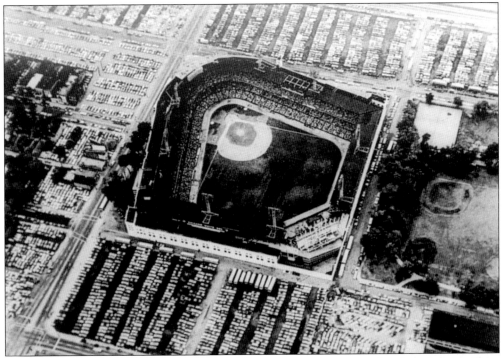

The 1983 White Sox drew a record 2,132,821 in the regular season, but lost the playoffs to Baltimore. Fans were hoping for a better ending in 1984, but the team lost 25 more games, slipping to fifth. They still outdrew the previous season's attendance by 4,167. (Courtesy Ray Mediros.)

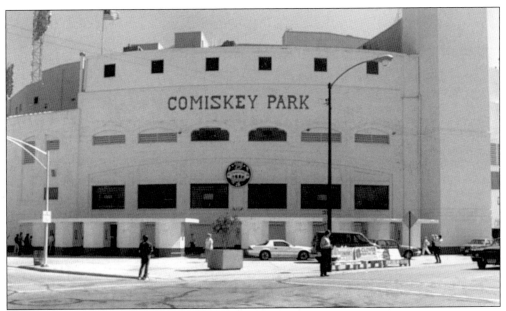

The emblem under the Comiskey Park sign let fans know the old ballpark was celebrating its 75th anniversary in 1985. The club finished third but lost over 467,000 paying customers. Tony LaRussa, Doug Rader, and Jim Fregosi all managed in 1986. The team finished fifth and attendance dropped to 1,424,313. (Author's collection.)

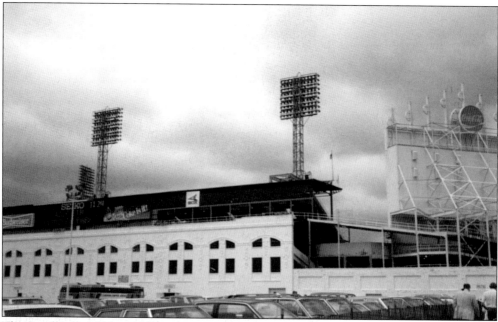

The Sox finished fifth in 1987 and 1988 under Jim Fregosi, and attendance dipped each season. (Photo by author.)

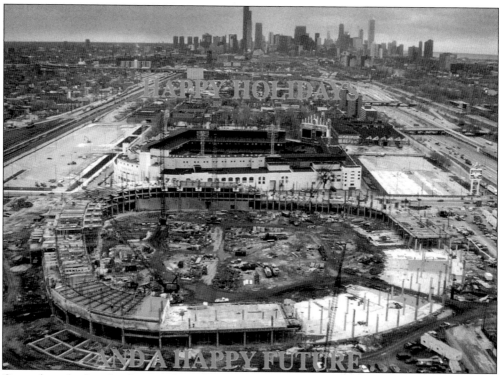

Ground was broken for the new Comiskey Park on May 7, 1989. The club lost 92 games in '89, finished in seventh, and attendance only reached 1,045,651. The club featured the rising new ballpark in its 1989 greeting cards. (Courtesy Chicago White Sox.)

The White Sox set a
club attendance record
in 1991 in the new
Comiskey Park as
2,934,154 paid their way
in to see the team win 87
games and finish second.
(Photo by author.)

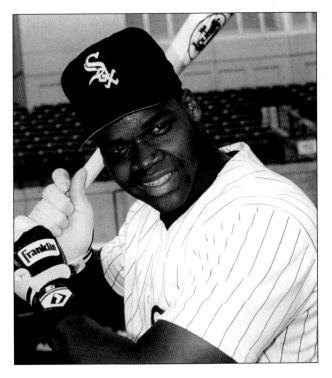

Frank Thomas, who made his
debut in old Comiskey Park in
1990, holds the distinction of
homering in two Comiskey Parks
in two different decades.
(Courtesy B&W Photos.)

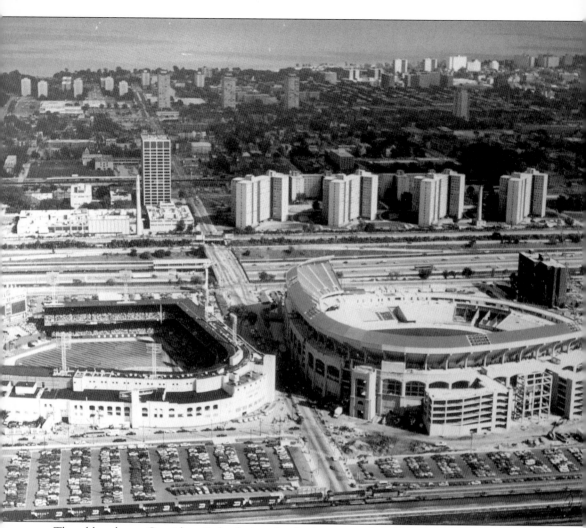

The old and new Comiskey Parks during the final game at the old ballpark on September 30, 1990, as the White Sox beat Seattle 2-1. (From the collection of Jim Raetz.)